natural dyes

To Jean

Very best wishes

Linda Rudkin

EG Louth April 2008

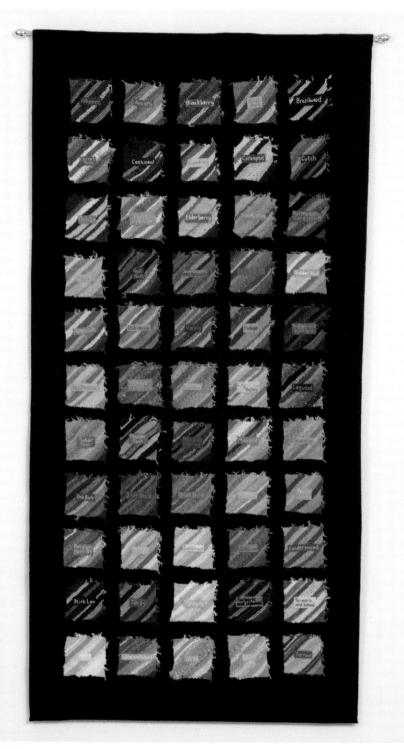

Sample hanging. Knitted squares on a black felt ground, showing the range of colours obtained from 55 different sources of natural dye, 160 x 80 cm (62 x 31 in.). Photo – Steve Walton.

natural dyes

Linda Rudkin

A & C Black Publishers • London

First published in Great Britain in 2007
A & C Black Publishers Limited
38 Soho Square
London W1D 3HB
www.acblack.com

ISBN-10: 07136-7955-7
ISBN-13: 978-0-7136-7955-7

CIP Catalogue records for this book are available from the British Library and the US Library of Congress.

Photography: Steve Walton and Linda Rudkin
Book design by Paula McCann
Cover design by James Watson
Managing Editor: Susan Kelly
Copyeditor: Carol Waters
Proofreader: Lucy Hawkes

Printed and bound in China

This book is produced using paper that is made from wood grown in managed, sustainable forests. It is natural, renewable and recyclable. The logging and manufacturing processes conform to the environmental regulations of the country of origin.

Contents

Acknowledgements

Thank you to all those who persuaded me that this book should be written and to Linda Lambert and Susan Kelly at A&C Black Publishers for supporting the process throughout. I am grateful to Cherrilyn Tyler and fellow students at Longslade College for their encouragement, to my friend Val Walker for her generous help whenever it was needed, and to Steve Walton for his excellent photography. I especially want to thank my husband John, for always believing in me and for his good-humoured tolerance of domestic untidiness, and some very peculiar smells in the kitchen, in order to see this project through.

'Riverbed' *(detail). Photo – Steve Walton.*

Introduction

A BRIEF HISTORICAL CONTEXT

The use of natural resources to provide colour for textiles predates any written records, as well as the earliest archaeological evidence in the form of ancient textile remains. We simply do not know how our ancestors first discovered that colour could be transferred from plants, insects and minerals to cloth. Presumably, at some stage, people found the colour of berry-juice stains pleasing enough to want to clothe themselves in these colours and their curiosity and ingenuity gradually extended the range of dyes used. There must have been many disappointments as the wonderful, fresh colours faded entirely, or became very drab, and we cannot even guess how it was discovered that using salt, vinegar, stale urine, iron or alum would improve the colours and prevent or delay the fading process. A growing body of knowledge must have been passed down through the experience of generations, but details of the development of the craft of natural dyeing, before the time of the first written records, remains largely a matter of conjecture.

Fragile examples of dyed fabrics dating back thousands of years have been found in China, India and Egypt, and we have written records attesting to the use of madder (red), weld (yellow) and indigo (blue) by the Romans. The evidence makes it clear that medieval dyers knew the sources of the most effective and valuable dyes. As textile production increased in importance around the world, so too did the status of the dyers. The livelihood of entire communities, as well as the economic prosperity of textile producing countries, often depended on the successful harvesting and processing of dye crops.

The immense value of natural dyes, as the only means of colouring textiles, remained unchallenged until the mid 19th century when the first synthetic dye was discovered by fifteen year old William Perkin as he searched for a cheaper substitute for quinine. 'Perkin's mauve', a product of coal tar, had a major impact on the fashion world of the day, especially after Queen Victoria appeared wearing this 'new' colour at the Great Exhibition of 1862. The subsequent development of many more synthetic colours, representing a cheaper and more convenient way of dyeing cloth, signalled the end of natural dyeing on an industrial scale.

Ironically perhaps, it was a reaction to the mass production, and perceived poorer quality, of artefacts in the Great Exhibition that motivated the 'Arts and Crafts' movement to look back to the production of handcrafted items using natural resources. This renewed interest in natural dyes amongst artists and craftworkers was championed, most notably, by William Morris. It was not sustained beyond the

time of his influence and nowadays it is left largely to individual textile enthusiasts to maintain and promote the skills of working with natural dyes.

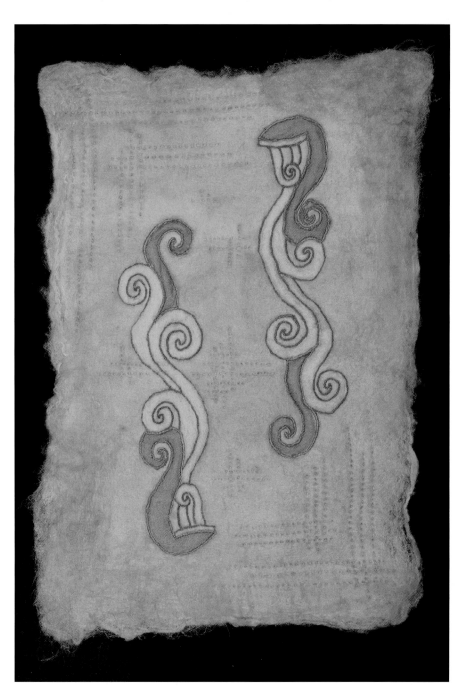

Felt hanging. Two pieces of handmade felt, machine-stitched over organza and cut back. Dyes – madder root and chamomile. 41 x 30 (16 x 12 in.). Photo – Steve Walton.

THE START OF A PERSONAL JOURNEY

Like so many others who have a passion for working with textiles, I was inspired by a visit to see the Bayeux Tapestry. The scale and the narrative detail of this extensive embroidery is stunning, but it was the vibrancy of the colours that stopped me in my tracks. Later I reflected on the obvious fact that the makers of this piece had only natural resources with which to create the colours that had remained so beautiful for almost a thousand years. I was intrigued and soon after returning home decided to see whether I could create similar shades. I used what was to hand: frozen blackberries from the previous season's crop, onion skins destined for the compost and golden rod flowers from the garden. I knew that natural dyes needed a mordant and an article in an old craft magazine suggested that rhubarb leaves could be used for this purpose. Four pans of simmering vegetation and a few hanks of woollen yarn later, I had my first batch of samples and was hooked. Once I had discovered that most plant materials will produce some colour, and that many exotic, imported dyestuffs can be obtained easily by mail order, I became totally absorbed. Using natural dyes is both fascinating and rewarding, and it has given a new and exciting dimension to all of my work with textiles.

WHY USE NATURAL DYES?

I should perhaps begin with reasons why using natural dyes might not be appropriate. To start with, the results are not entirely predictable, whereas if you use commercial dyes and follow the instructions precisely, you are guaranteed to produce the colour on the label.

There are many variables that can affect the outcome with natural dyes: the age of the plant material, the season, the amount of recent rainfall, the Ph. of the soil, the hardness of the water and, most significantly, the ratio of dyestuff to fibre – any of these factors can make a noticeable difference. This explains why it is often a frustrating business trying to repeat an exact colour. Even when you believe all materials and conditions are identical the second time around, there are likely to be factors that will change the outcome.

Then there is the question of capacity: it is possible to dye only as much material as can be comfortably moved around in the dyepan. If you want to dye in bulk or brighten up the kitchen curtains, then it would make practical sense to buy a commercial washing-machine dye.

It is commonly believed that natural dyes are prone to fade and, indeed, this is true of some. However, if a few basic principles are understood and processes observed, most natural dyes will hold their colour as well as any others. All textile work needs to be kept out of direct sunlight which will cause even the most expensive commercial dyes to fade. Natural-dyed textiles, given the same care and consideration as any others, should remain vibrant for just as long.

Assorted yarns dyed with white and red onion skins. Photo – Steve Walton.

Finally, it might be argued that modern synthetic dyes are simply more convenient but, as I hope this book will show, working successfully with natural dyes is not at all difficult and it is a great deal more interesting. There is something very satisfying about growing or finding the means to produce your own natural colours for a piece of textile work, especially these soft, harmonious colours that would be difficult or impossible to achieve using commercial dyes. Starting a project with undyed fibres and plant material makes the business of colouring the textiles an integral part of the creative process and adds to the sense of achievement on completion of the work. This leads me to the overriding reason for choosing to work with natural dyes, that is, the colours themselves. They seem to hold the light in a special way and, if some shades mellow with time, this is not quite the same as fading and the end result is still pleasing to the eye. Of course, this may be a somewhat subjective and biased point of view, but it is a matter of fact that a wonderful variety of colours can emerge from just one natural dyeing session. This ability to produce a wide range of entirely compatible shades from the same dyepan at the same time represents a really valuable resource for the textile artist.

Silk scarves dyed first with assorted natural colours, then twisted and wound to create a pattern when dipped into indigo.

Working with natural dyes, like the rest of the creative process, is an adventure. As long as basic principles and processes are observed, there will be few disappointments and many delightful surprises.

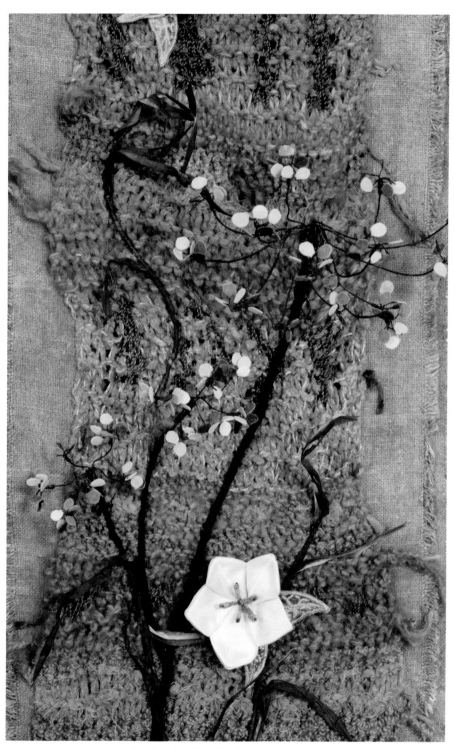
Indigo hanging *(detail). Photo – Steve Walton.*

Requirements for Dyeing

EQUIPMENT

It need cost very little to collect together the basic equipment required to start natural dyeing; many of the items are likely to be in your kitchen already. If you do use articles from the kitchen cupboard, remember that they should not be used again for food preparation but kept solely for dyeing.

As a minimum, you will need:

Dye pans. These should be the largest that you have or can buy. It is possible to dye successfully in pans made of any material, but aluminium, copper and iron pans may modify the colours produced, and the useful life of these pans will probably be shortened as a result of surface deterioration during the dyeing process. An enamel pan works well, and the white surface shows the colour of the dye very clearly, but any rust spots on a chipped pan will release iron into the dye and dull the colour. The best pans to use are stainless steel because they do not affect the colour at all and are easy to clean. They should last in good condition for a very long time.

Stirrers. Wooden spoons or lengths of dowel are fine but they will stain very quickly and the colour may transfer to the next batch of dyeing. Glass rods or long-handled stainless steel spoons are ideal.

Scales. Ordinary kitchen scales can be used to weigh the dry fibres. They can also be used to check the weight of dyestuff, although this seldom needs to be precise. However, mordants are usually weighed out in small quantities and, for this purpose, electronic scales are a necessary indulgence.

Strainers. When the dye has been extracted from the dyestuff, the liquid must be strained to remove the solid debris. A large, stainless steel strainer with a lip to support it over a receptacle is perfect. A fine, nylon mesh sieve is also useful for removing particles of powder dyes. If neither is available, improvise with a piece of muslin or the leg of a pair of old tights stretched over a colander.

Gloves. Ordinary kitchen gloves are suitable for most tasks. Finer, surgical-type gloves are safer for weighing powders, including mordants. Kitchen gauntlets will protect your arms when immersing fibres into a vat of indigo or woad.

Face-mask. Fine powders may be toxic or irritant and using a face-mask avoids the risk of inhalation.

Apron. Even if, like most dyers, you reserve old clothing for dyeing days, covering up with a plastic apron will protect from splashes and prevent embarrassment when the doorbell rings mid session!

Oven gloves. The handles of a dyepan can become very hot, especially if two or three are simmering close to each other. Always protect your hands when removing pans from the source of heat.

Measuring jug. Glass is better than plastic because it will not stain.

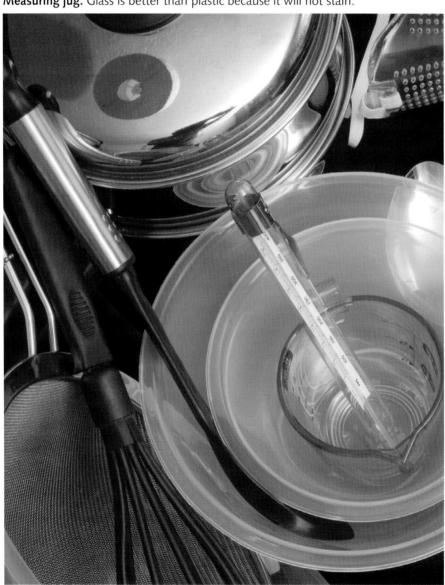

Equipment for dyeing. Photo – Steve Walton.

Storage jars. Clean jars with screw-top lids in a range of sizes are useful for storing dried dyestuffs and mordants. Some of these are light sensitive and best kept in dark containers. If none are available, use small, clear jars and keep in a lidded box. All storage containers should be labelled clearly, stored out of direct light and out of the reach of children.

Bowls and buckets. Small glass or plastic bowls are useful for weighing and mixing mordants and powder dyes. A plastic bucket is lightweight and ideal for collecting, shredding and soaking fresh plant material, and a bucket with a well-fitting lid is necessary for working with indigo and woad.

Thermometer. A sugar thermometer is required for successful dyeing with indigo, woad and madder root.

Hand whisk. This is the quickest way to aerate a woad vat.

Water supply. Tap water is usually fine. If you live in a hard water area and a recipe calls for soft water, use cheap, bottled water or clean rainwater.

A source of heat. An adjustable heat source is necessary for good control of the dyeing process and for most people this means the kitchen cooker. A camping stove with two burners is fine for dyers who prefer not to work in the house.

The following items are also useful:

Large freezer bags. These are convenient for keeping plant material in the freezer until you have enough to use. They are also handy for storing dyed yarns and small pieces of fabric, mainly because they are quick and easy to label.

Books of litmus papers. If you intend to keep serious records, you may want to check the acidity or alkalinity of a dyebath.

Measuring spoons. Useful when recipes refer to small quantities by volume.

Plastic table covers. These will protect working surfaces, particularly when working with indigo and other powders.

FIBRES

Natural dyes are most successful on natural fibres, or those that are man-made from natural sources e.g. rayon/viscose. Synthetic fibres rarely dye satisfactorily although some interesting flecked effects can be achieved by using mixed fibres.

Natural fibres fall into two categories: protein fibres, originating from animals; and cellulose fibres derived from plants. The dyeing process is the same for both groups but they need to be prepared (mordanted) differently.

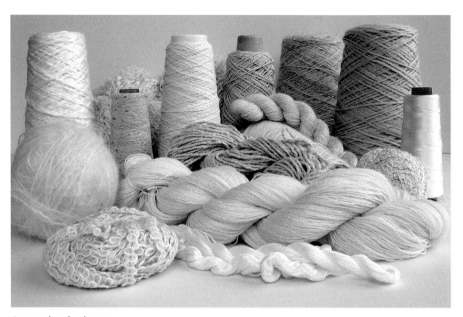

Assorted undyed yarns.

Protein fibres

Wool. This takes up natural dye more effectively than any other fibre. Yarn should be wound into hanks and tied loosely with cotton in several places. The cotton will dye to a different shade and be easier to find and remove when finished.

To avoid felting, wool should be moved around gently in the dyebath and the first rinse should be in water that is approximately the same temperature as the dyebath. Of course, the reverse applies if you are working with handmade felt and want to increase firmness and shrinkage. In that case, vigorous stirring and temperature shocks will assist both processes.

Remember that the undyed yarn or fleece has its own natural colour which can make a significant difference to the final outcome. Choose white if you are aiming for the clearest shades or pale colours.

Silk. These fibres also dye well but the shades are often lighter than those achieved on wool. Although silk is a very tough material it should always be simmered, not boiled, to avoid loss of lustre.

Alpaca, angora, cashmere and mohair. These delicate fibres should be treated as gently as possible. They take up dye readily but when the process involves simmering, which it usually does, there will be a price to pay in terms of softness and structure. (I have used horribly matted mohair threads in pieces of textile sculpture and liked the effect, but I would certainly not use them to make a shawl!) In the case of vat dyeing, e.g. indigo, woad and safflower, the softness and structure is maintained.

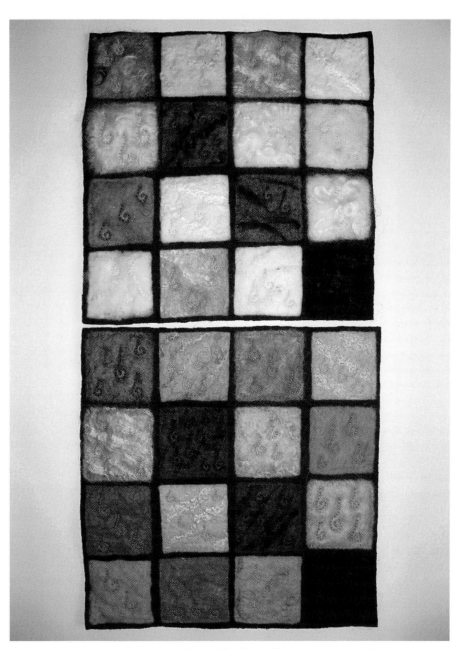

These samples show how the original colour of the fibres affects the outcome of the dyeing process. The felted squares at the top have been left undyed; the squares below have been dyed with madder root (orange/brown) and chamomile (yellow). The squares were dry-felted onto a red felt backing before being chain stitched with a curl motif.

The fleeces are, from left to right: top row: Gotland, blue-faced Leicester, Alpaca, combed Merino. Second row: Honey mohair, black Wensleydale, white Wensleydale, Shetland Herdwick. third row: Camel down, carded Merino, black Jacob, Lincoln Longwool. Bottom row: White Shetland, Merino/Possum, white Jacob, black Shetland.

Cellulose fibres

Cotton. If cotton fibres are treated in the same way as wool or silk, the results are likely to disappoint. The colours will be much paler or even insignificant. If suitably prepared (mordanted), cotton will take up colour as well as any other fibre (see next chapter).

Flax, jute, linen and hemp. These are also vegetable fibres and should be treated like cotton. Some are quite dark in colour in the undyed state, making them unsuitable when clear, bright colours are required.

Rayon/viscose. These fibres are made from wood or cotton waste and should be treated like cotton if strong colours are wanted. However, some delicate, pearly shades can be achieved by dyeing alongside wool or silk. Rayon/viscose threads tend to crinkle when simmered and, if this effect is not wanted, holding the dyed threads under running water and allowing them to drip-dry easily reverses it.

DYESTUFFS

Natural dyestuffs are often abundant and freely available in gardens or hedgerows. A few are conveniently located in the supermarket and many exotic dyestuffs from warmer climes are now easy to obtain by mail order.

Growing or finding the source of colour for your textile work, and producing a wide range of harmonious shades in one dyeing session, is both rewarding and inspiring. Most plant material will yield some colour when simmered, but some may be so pale or fade so rapidly as to be considered not worthwhile. For the craft dyer who is happy to experiment and accept occasional disappointment, the possible sources of dye are almost endless.

Flowers, leaves, fruit, vegetables, roots, bark, nuts and seeds are all worth investigating. It costs little or nothing to test the value of a plant as a dyestuff; simply put a handful in a dyepan and simmer for half an hour. The amount of colour released will be a good indicator of dye potential.

Another promising sign is a pungent smell! This is the downside of working with marigolds, dahlias and onion skins for example – but the colours are wonderful.

All plant material can be used fresh, frozen or dried but the brightest shades are generally obtained from freshly gathered flowers and leaves.

How much to use

There is no need to be too precise about the quantities to use.

Fresh material. As a general rule, use at least twice the weight of the dry fibres e.g. a minimum of 200g (8oz) leaves for each 100g (4oz) fibres. However, if you have a surplus of a particular dyestuff, use as much as you like and enjoy the added richness and depth of colour.

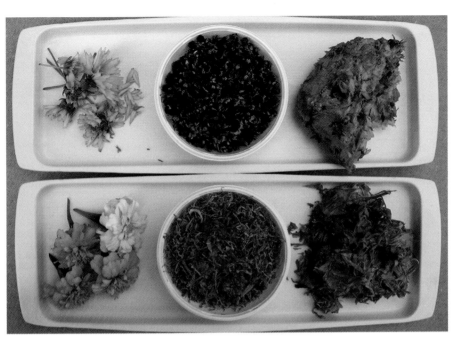

Fresh, dried and frozen coreopsis and marigold flowers, which are all suitable for dyeing.

Dried dyestuffs. From left to right: top row: poplar buds, lady's bedstraw roots, logwood, lichens.
Middle row: cutch resin, weld, stick lac, birch bark.
Bottom row: arbutus bark, cochineal beetles, madder root, elderberries.

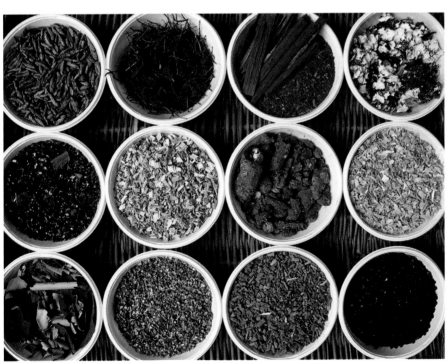

7

Frozen material. Being specific about quantity is a bit more difficult in this case, unless you have been efficient enough to record the weight before freezing. Unfortunately, I am not that efficient and simply use any size of frozen lump that will fit into the pan.

Dried material. This is more concentrated and using 100g (4oz) for each 100g (4oz) dry weight of fibre is sufficient for a good depth of colour. There are several imported dyestuffs that are so strong that much smaller quantities are required (see 'Mail order supplies'). Many coarse and woody dyestuffs can be dried out after use and stored to be used again. Some of these can be reused many times, making them extremely good value. The colours produced on the first occasion are very strong, and the fact that they will be paler with each successive use is actually a bonus for the textile enthusiast who can obtain a wider range of harmonising shades.

Dyestuffs from gardens and hedgerows

Flowers. There is no need to spoil displays in the garden; flowers give up their colour most readily when just past their best and starting to fade – simply deadhead and store in the freezer until you have enough for the pot and a dyeing session is convenient.

The following flowers are among those that are excellent sources of dye: chamomile, coreopsis, dahlias, dandelions, golden rod, marigolds, pelargoniums and yarrow.

Leaves. Any fresh leaves are worth trying and the usual outcome is a range of yellows, olives and browns, but not greens! The green-producing leaves of comfrey and ivy are the exception and not the rule.

Weld is an ancient and reliable source of bright yellow that can be found growing in poor soil by the wayside. It is possible to grow it in the garden from seed obtained from specialist suppliers – or from another enthusiast.

The same applies to woad, but this ancient dye plant thrives on rich soil. It is exceptional because it yields a lovely powder blue but, as a vat dye, it needs different processing. It is also very useful for overdyeing yellow shades to obtain good greens.

Fruit. Berries look temptingly obvious as a source of dye. However, all berry dyes have a tendency to fade but the colours stabilise with time and the slightly dusky shades that remain are attractive in themselves. Both blackberries and elderberries give pleasing results used either fresh or frozen. The same applies to damsons and you may be happy to have an alternative use for this fruit that does not require the messy and tedious removal of stones!

A vegetable plot can also provide a number of dyestuffs but, because ours is very limited, I have assigned 'vegetables' to the supermarket.

Roots and bark. It is illegal to uproot any plant from the wild but it is often possible to obtain seeds from specialist suppliers. Unless you have an area set aside for wild plants, these are best grown in containers to avoid a rampant take-over of your flower border. The red dyes from the roots of madder, lady's bedstraw and cleavers can all be harvested in this way. Most need to be planted for at least three years before the roots are dug.

Living trees can be seriously damaged or killed by having their bark removed, and so bark chips for dyeing are best obtained from a reputable mail order supplier who will have checked that only felled trees have been used.

Dyestuffs from the supermarket

Vegetables. The most well known and reliable dye usually costs no more than a 'please' and 'thank you'; all those loose onion skins in the bottom of the box will be thrown away unless you ask for them. You may be regarded as slightly eccentric but the risk is worth it. Onion skins give up their colour readily. White onion skins produce bright yellow, orange and rust colours. Red onion skins can be added to white to deepen the shades or used on their own to produce strong, interesting greens!

Buy your carrots in bunches, snip off the leaves and keep them in the freezer until you have enough for the dyepan (usually about three bunches' worth). These will produce strong golds and greens on wool, although they have little effect on other fibres.

One of the most tempting vegetables to try is beetroot but it will almost certainly disappoint. The crimson liquid that looks so promising produces a dye that fades to an unremarkable beige in a very short time.

Nuts. The shells of nuts are certainly worth keeping although smashing them up can be a messy process. Pecan shells are particularly useful; they provide soft pink/brown shades and can be reused several times.

Spices. The spice section is worth a visit. Powdered turmeric is an excellent and convenient source of yellow dye, as anyone who has used it for making piccalilli will testify. Saffron is very expensive but one small 0.5g pack will dye 50g (2oz) of fibres to beautiful shades of yellow and green. Some larger supermarkets stock 'economy' packs of spices. If powdered saffron is available, it is worth buying for the lovely coral pinks it will produce. Cinnamon and paprika are similarly worthwhile.

Amongst the small bottles of food colouring, you are likely to find some labelled 'cochineal'. This will dye fibres bright red but it is a synthetic product, not the 'real thing'. Natural cochineal is stocked by mail order suppliers.

Mail order supplies

An exciting range of exotic, imported dyestuffs, as well as more familiar dried plant material, is now available by mail order. Examples of many of these dyes are illustrated and described in Chapter 4. The following list gives some idea of the selection available by category:

Barks: Birch, buckthorn, oak.

Dried flowers and leaves: Chamomile, golden rod, henna, hibiscus, indigo, ivy, marigold, safflower, St. John's wort, tansy, weld.

Heartwoods (woodchips from the inner tree trunk): Brazilwood, cutch, fustic, log-wood, osage orange, sanderswood.

Insect dyes: Cochineal, stick lac, gall nuts.

Nuts, seeds and berries: Annatto, elderberries, Persian berries, walnut hulls.

Roots: Alkanet, bloodroot, madder root, turmeric.

How much to use

For each 100g (4oz) dry weight of fibres use 100g (4oz) dried dyestuff. There are some exceptions. Those listed below contain so much colour that smaller quantities are required.

For each 100g (4oz) dry weight of fibres use:

Annatto seeds – 50g
Cochineal – 25g
Fustic – 50g
Henna – 50g
Logwood – 30g
Persian berries – 30g
Turmeric – 40g.

Indigo should also be mentioned here because it requires only 1-2 teaspoons of powder to make up a container of dye but, as vat dyes, the blue-producing indigo and woad are different in every respect from all others. They are dealt with in detail in the next chapter.

MORDANTS

Mordants are used to fix a dye; they encourage the particles of dye to bond to the fibres. This increases the take-up of colour and helps to prevent fading in the light and in the wash.

Some dyestuffs will transfer their colour to fibres without the use of a mordant; these are referred to as 'substantive' dyes. However, it is still beneficial to use a mordant with these dyes because of the improvement in colour and increased light and wash fastness.

The most commonly used mordants are alum, copper, chrome, iron and tin. Using several mordants is one way of extending the range of colours obtained from a dyebath. (Some of the sample boards in Chapter 4 show this quite clearly.)

Always store mordants out of the light, in small, clearly-labelled screw-top jars.

There is often disagreement amongst dyers about how much mordant to use, but what is not disputed is the fact that dyers in the past tended to use far more than necessary and better results are achieved by using smaller quantities. The addition of an 'assistant' to the mordant solution increases its effectiveness, reduces the quantity of mordant needed and aids absorption by the fibres. The most commonly used assistants are cream of tartar, and dilute acetic acid in the form of white vinegar.

Most mordants are used before dyeing takes place, referred to as 'pre-mordanting'. The mordant and assistant are dissolved in water. Then the fibres are immersed and the mordant bath is brought slowly up to simmering point. The temperature is held for about 45 minutes before the fibres are removed, rinsed and placed in the dyebath. Some mordant solutions are added to the dyebath towards the end of the dyeing process; these are known as 'after-mordants'.

There is nothing difficult about using mordants successfully but some are toxic and need handling with extra care. Pans should be covered throughout the mordanting process to avoid the inhalation of fumes.

Gloves and a face-mask should always be worn when weighing mordants: I also keep an old tray to place under the scales so that any spillages cannot contaminate the kitchen surface. However, accidents can still happen and all traces of spilled mordant should be cleaned up immediately, using a disposable cloth and plenty of water. Mordant solutions can be stored for reuse. Large, empty coffee jars are useful for this purpose; label them clearly and store out of the light. The solutions can be reused two or three times. This ensures that very little residue remains to be disposed of and is therefore good practice from an environmental point of view.

Historically, mordants included wood ash and stale urine, both very effective but lacking in appeal to some modern dyers, including me. Our ancestors also used alum and this is still the most commonly used mordant today; it is safe to use and produces clear, bright colours.

I am sometimes asked about 'natural' mordants. Sumach leaves (*rhus typhinus*) contain natural tannin, as do oak galls, and this is particularly useful as a mordant for cotton. The difficulty is in knowing how much to use. Rhubarb leaves are

another natural source, but the mordant they contain is oxalic acid and that is a listed poison! I do use various mordants when working experimentally with a dyestuff for the first time, just to discover whether they have significantly different effects but, for most dyeing, alum is my preferred mordant and the one I recommend to others.

All mordants and assistants are easily obtained by mail order.

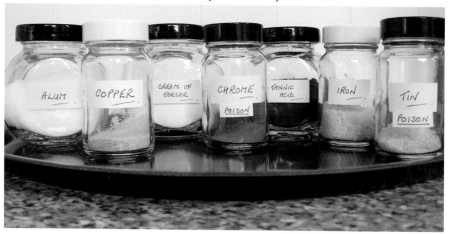

Mordants should be stored in clearly-labelled screw-top jars.

The quantities given below refer to the amounts needed to mordant 100g (4oz) dry weight of fibres.

Pre-mordants

These are mixed with a little hot water and then added to cool water in the mordant pan. The fibres are simmered in this solution for about 45 minutes before dyeing takes place.

Alum. (*Potassium aluminium sulphate*) 6g (¼oz) with 6g (¼oz)cream of tartar to assist. Alum produces clear, bright shades. It is safe to use and the spent solution can be disposed of by pouring on the garden. (Using an aluminium pan for dyeing may also brighten colours but insufficient alum will be released to affect fastness.) Using too much alum may make wool sticky.

Copper. (*Copper sulphate*) 2g (⅒oz) with 40ml (1 fl. oz) white vinegar (dilute acetic acid) to assist. Copper moves yellow shades towards green and darkens all colours. It is toxic but the addition of white vinegar means that only tiny quantities of copper are required. It is used by gardeners in fungicides and, when the mordant bath has been used two or three times, it can safely be poured away onto soil.

Chrome. (*Potassium dichromate*) 3g (⅒oz) with 6g (¼oz) cream of tartar to assist. Chrome strengthens colours and leaves wool feeling soft and silky. It is toxic but if

you cannot resist trying it, keep the lid on the mordant pan so that you do not inhale fumes. At the end of each dyeing session, store the solution securely and reuse at least twice to ensure that almost no chrome is left in the solution. Treat the spent mordant bath as hazardous waste for disposal.

Tannic acid. 6g (¼oz) used with alum and washing soda. Tannic acid is used mainly to mordant cotton. It needs to be dissolved very thoroughly so that particles do not stain fabric because these marks cannot be removed. Tannins occur naturally in many plants and tree barks; it is therefore safe to use and the spent mordant solution can safely be disposed of on the garden.

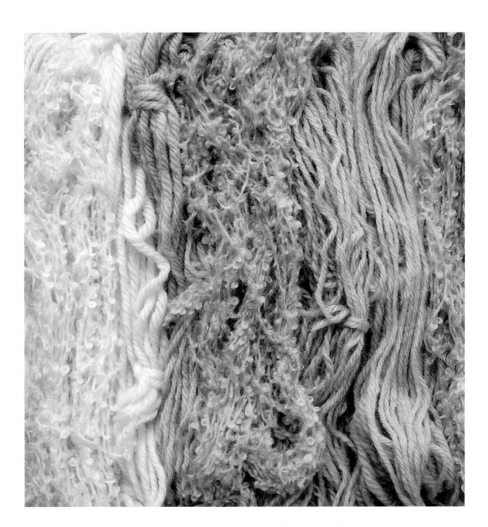

Yarns ready for dyeing. These have been mordanted with (left to right): alum, copper and chrome.

After-mordants

Tin. (*Stannous chloride*) 1g (no more than a small pinch). Tin is valued more as a colour brightener than as a mordant. It is most effective when used on fibres that have been premordanted with alum. Tin is a noxious substance and should be used with due caution.

Remove fibres from the dyebath about ten minutes before the end of the dyeing process. Add the tin, dissolved in a little water, and return the fibres to the pan. The smell of the dyebath becomes very unpleasant when tin is added and this may deter any further experimentation, but the effect on the colours is dramatic; they really zing!

Iron. (*Ferrous sulphate*) 2g (⅛oz) of crystals or 2 tablespoons of 'iron water'. Iron, like tin, is added towards the end of the dyeing process to modify colour and also works best on alum-mordanted fibres. It darkens, or saddens colours and with some dyes will produce near black shades. 'Iron water' is a handy substitute for bought crystals; simply mix a cup of white vinegar with water in a wide-necked jar and add a few small items of rusty metal. After about a week, the liquid can be spooned off and used for dyeing. Keep the jar topped up with water to have a continuous supply of iron. Excessive use of iron makes wool brittle.

To conclude: Successful dyeing depends upon molecules of colour making a strong bond with molecules of fibre. The purpose of using a mordant is to strengthen this bond and it is as important to the success of any dyeing project as the dyeing process itself.

The Dyeing Process

THE 'STANDARD PROCEDURE'

This process applies to all natural dyeing with the exception of the 'vat dyes' – indigo and woad, which are covered later in this chapter. It is suitable for all natural fibres but cotton requires a different process of mordanting (see p.21).

Basic requirements for dyeing 100g (4oz) of fibre

The following items should be assembled before starting a dyeing project:

a. Equipment – two pans, strainer, spoons, scales, bowls;
b. The dyestuff in sufficient quantity – 200g (8oz) fresh or frozen, 100g (4oz) dried;
c. 100g (4oz) natural fibres; and
d. Mordant and assistant – 6g (¼oz) alum and 6g (¼oz) cream of tartar, or equivalent.

The process:

1. Scour the fibres to remove any finishes

It is usually enough to wash in warm water with a little washing-up liquid. Rinse thoroughly, using warm water again when working with wool. Squeeze out the fibres, but do not dry them. Keeping the fibres wet helps to ensure that no pockets of air remain to prevent the mordant and the dye from reaching all parts.

2. Make up the mordant solution

Mix the alum and cream of tartar with a little hot water. Add this to warm water in a large pan. Use enough water to enable the fibres to be moved around freely; this is essential to ensure that the mordanting is even. (Uneven take-up of mordant solution is likely to result in patchy dyeing.) Place the fibres in the mordant solution and cover the pan.

3. Mordant the fibres

Raise the heat of the mordant solution gradually to simmering point and maintain this temperature for about 45 minutes. Stir the fibres occasionally to ensure even take-up, keeping the pan covered in between to avoid inhaling fumes. When mordanting is complete, allow the fibres to cool in the pan before removing and rinsing thoroughly in warm water.

Assorted natural yarns, scoured and ready for mordanting.

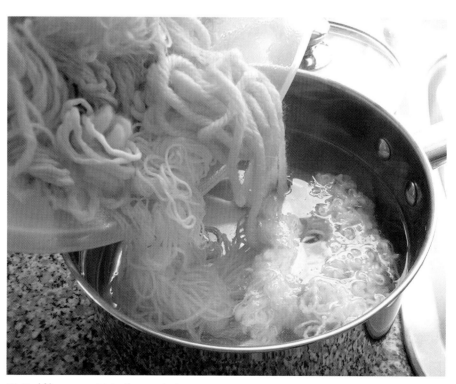

Wetted fibres are put into the mordant pan.

4. Extract the dye

Prepare the dyestuff, if necessary, and cover with water in the dyepan. Raise the heat and simmer for up to one hour to extract the dye. Fresh material usually needs less time to give up its colour; some flowers become almost transparent after only ten minutes. Strain the dye through a sieve to remove all solids.

Woody material can be dried out and stored for reuse. Softer material can be consigned to the compost heap.

N.B. Steps 3 and 4 can be carried out simultaneously.

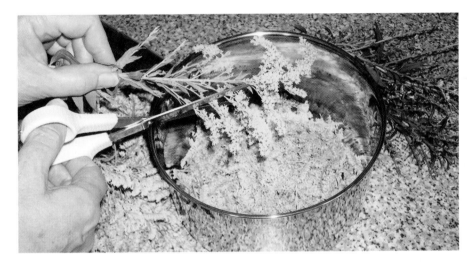

Snipping golden rod flowers into the dyepan

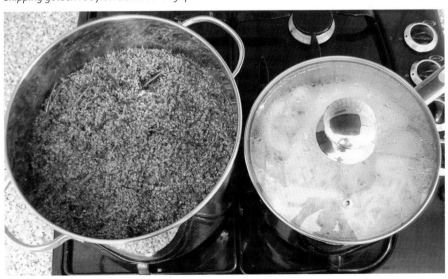

Extracting the dye and mordanting fibres at the same time.

5. Dye the fibres

Put the rinsed fibres into the dyebath. Add more water as necessary to enable them to be moved around freely. Raise the temperature gradually until simmering point is reached. Continue to simmer until the desired depth of colour is achieved, stirring from time to time to ensure that the dye is taken up evenly. Remember that shades will be paler after washing, rinsing and drying.

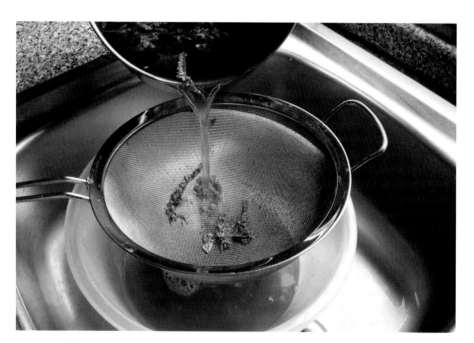

Straining off the liquid dye

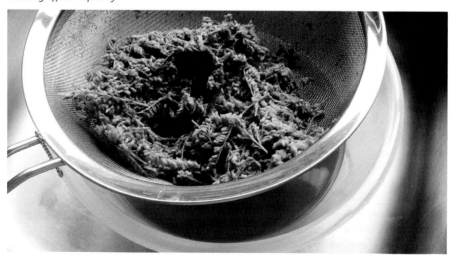

Strained, soft debris can be composted.

Some dyes take only a very short time to bond with the fibres. For example, onion skin dye takes no more than 20 minutes, by which time the water is left almost clear. Dyeing with fresh flowers usually takes even less time; fibres dyed with golden rod should be removed from the heat after about ten minutes, otherwise the lovely bright shades will become darker and more dull. When the colour looks right, remove the dyepan from the heat and allow it to cool before removing the fibres and rinsing them thoroughly until the water runs clear. Wash, rinse and dry as usual.

6. The 'exhaust' dye

Dye that has been used once is known as the 'exhaust'. Before disposing of this, it is worth considering whether it can be used again. If the dye still has good colour, i.e. enough to obscure the bottom of the pan, it probably still has potential. Put a lid on the pan and the dye should remain usable for at least a week, providing the opportunity to dye more fibres. Shades will be paler with each use. If mould appears on the surface of the dye, simply remove it with a piece of kitchen towel. When you have finished with the exhaust, it can be disposed of safely and easily by pouring onto garden soil.

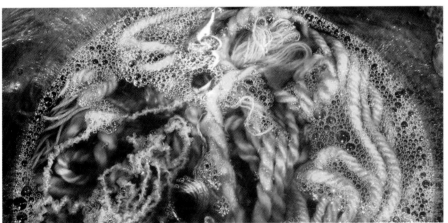

Yarns simmering in dye prepared from golden rod flowers.

Assorted yarns, dyed, washed and ready for drying.

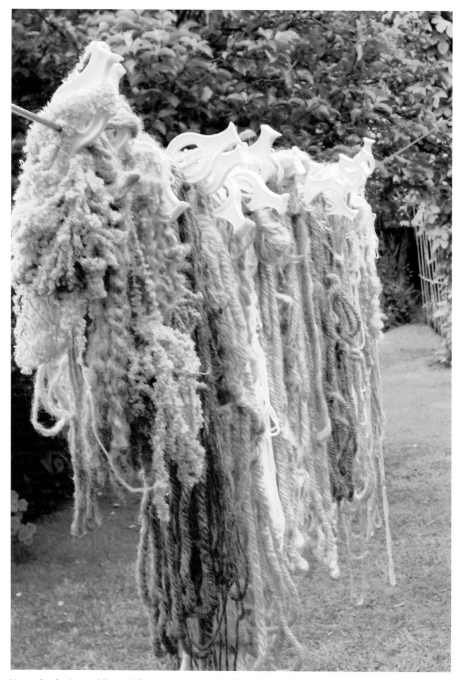

Yarns dyed using golden rod flowers drying on the line.

MORDANTING COTTON

Cellulose (vegetable) fibres do not take up dye as readily as protein fibres and need to be mordanted differently. They can then be dyed by the standard process (step 5 above). If cotton and linen are mordanted in the same way as wool and silk, the very pale colours achieved may disappoint.

There are four basic methods for mordanting cellulose fibres involving the use of washing soda, natural tannins, tannic acid alone, or tannic acid with alum.

The addition of washing soda to the mordant solution helps the dye to bond, and improves the depth of colour achieved.

There are some dyes that are rich in natural tannins, e.g. gall nuts (oak galls) and sumach leaves (staghorn – *rhus typhinus*), that produce good colour on cotton without any special mordanting. Either of these can be used to make a mordant solution to prepare cotton fibres for dyeing. I have had good results using fresh sumach leaves. A possible disadvantage with these 'natural' mordants, of course, is that they contain their own dyes and will impart a tan shade to the cotton, which will affect the final outcome unless you use a dye which is significantly darker.

The same point applies to tannic acid, a stronger, chemical form of tannin with all impurities removed, available in powder form by mail order. I have found that, used on its own, it produces quite a strong tan colour, which can dominate the dye and make the final outcome too dark.

However, using tannic acid with alum is much less likely to have this effect, although it takes a little more time and effort. I find that this is justified by the depth of good, clear colour that is obtained by this process.

Mordanting cotton with washing soda

For each 100g (4oz) fibres, use 25g (1oz) alum and 6g (¼oz) washing soda.

Method: Dissolve the alum and washing soda separately in hot water and add to warm water in the mordant pan. Put in the scoured, wet cotton or linen and gradually bring the temperature up to boiling point. Simmer for 30 minutes, stirring occasionally. Turn off the heat and leave the fibres in the pan until cold, overnight is fine. Remove the cotton from the pan and rinse well before dyeing as usual.

Mordanting cotton with sumach leaves (or oak galls)

For each 100g (4oz) cotton, use approximately 50g (2oz) fresh leaves. If you have dried sumach leaves, then 25g (1oz) will be enough but they should be soaked overnight before using.

Method: Pull the fresh leaves from the stalks and chop them roughly into the mordant pan. Cover with warm water, bring up to simmering point and leave on the heat for about an hour to extract the tannin. Strain to remove the solids, which

can be composted, and return the mordant solution to the pan. Immerse the wetted cotton, raise the temperature gradually up to the boil and simmer for 30 minutes. Allow the cotton to cool in the mordant solution, preferably overnight. Rinse thoroughly and proceed to dye as usual. (A similar quantity of oak galls can be substituted for the sumach leaves, but they might leave the cotton a darker colour. This need not be a problem if you plan to dye to a dark shade anyway.)

Mordanting cotton with tannic acid

For each 100g (4oz) dry weight of fibres use 6g (¼oz) tannic acid.

Method: Dissolve the tannic acid powder in about a third of a pan of hot water. Try to ensure that it dissolves completely because any stray particles are likely to stick to the fibres and make unsightly brown marks, which are impossible to remove. I have had this happen with cotton fabric and recommend that you dye more than you are likely to need, just in case some parts are spoiled in this way. Add the scoured and wetted cotton and raise the temperature gradually to simmering point. Simmer for half an hour, stirring gently from time to time. Let the fibres cool in the mordant solution, preferably overnight. Rinse well and dye as usual.

Mordanting cotton with alum and tannic acid

For each 100g (4oz) cotton, you will need 50g (2oz) alum, 12g (½oz) washing soda and 6g (¼oz) tannic acid. This process takes longer because the cotton is mordanted in three stages over three days. However, each stage is simple and takes very little time. I find that the only inconvenience is remembering to start the mordanting three days before I want to dye the cotton, but the results are so much better than those achieved by any other method that it is definitely worth the extra planning involved.

Method: Use half the alum and washing soda and dissolve thoroughly in a pan of warm water. Put in the wetted cotton and raise the temperature gradually to simmering point. Remove from the heat and allow to stand overnight. The next day, dissolve the tannic acid powder in about a third of a pan of hot water. Make sure that it has dissolved completely because any particles remaining will leave marks on fabric that cannot be removed. Top up the solution with cold water until there is enough to cover the fabric or yarns without pressing them down. Put in the cotton and heat slowly until simmering point is reached. Set aside and leave the fibres to cool in the pan overnight. The following day, rinse the cotton and then repeat the first part of the process, using the rest of the alum and washing soda. When the fibres have been steeped overnight, remove them from the pan and rinse thoroughly once more before proceeding to dye as usual.

Using this method, I have obtained the same depth of colour on cotton as I would expect to get on wool, and I am indebted to Jenny Dean who suggested this 'three-step' method in her book *The Craft of Natural Dyeing* (Search Press Ltd, 1994).

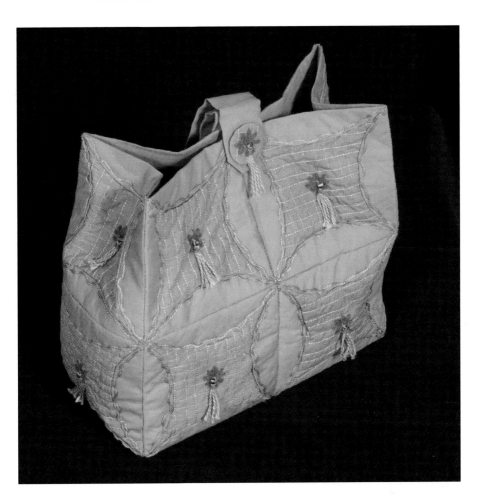

'Japanese folded patchwork' bag in cotton fabric, mordanted with alum and tannic acid, and dyed with onion skins. The fabric for the inset pieces was machine stitched with undyed rayon thread before mordanting. Cotton perlé was used for top-stitching and tassels and the flower centres were 'lazy-daisy' stitched in wool. 20 x 19 x 10cm (8 x 7 ½ x 4in.) Photo – Steve Walton.

Useful tips – and a few other suggestions

Extend the range of shades obtained in one dyeing session

Use three different mordants and process these while the dye is being extracted. This takes very little extra time and can produce three times as many shades in the same dyeing session. If you want to keep a record of results, try the 'knot and notch' method. Using three pieces of thick wool, tie one knot for alum, two for copper, three for chrome etc. Small pieces of fabric can be similarly identified using notches. These provide markers against which other samples of yarn and fabric can be matched after dyeing. I use this system to compile sample boards.

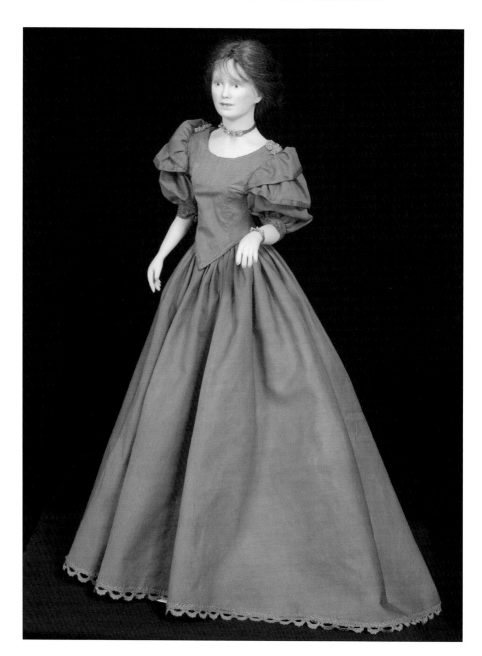

Handmade porcelain doll, 53 cm (21 in.) high. The lightweight cotton dress fabric was mordanted with alum/tannic acid/alum before being dyed with madder root. The choker and bracelet are made from silk ribbon, from a different dyebath, stitched with tiny, pink seed beads. Photo – Steve Walton.

Mordant larger quantities in advance

All mordanting processes can be carried out well in advance of dyeing. The fibres should be rinsed, dried and stored in labelled bags ready for dyeing when needed. They will keep indefinitely. Having premordanted fibres available saves time, effort and space on the hob if you want to work with more than one dye at the same time. It would also help patchworkers and quilters who use a lot of cotton and choose to mordant using the three-stage alum/tannic acid/alum process.

Dye more fabric or yarn than you need when working with yellow shades

Consider that you might want to produce some clear green shades at some point. The only way to be sure of getting these is to 'overdye' yellow with blue (*see 'Overdyeing' p.38*).

Create colour variations and patterns while dyeing

Fabrics and yarns can be shadow-dyed by draping over a long-handled spoon or piece of dowel placed across the top of the dyepan. Some lovely effects can be created by draping in a different position over a second dye.

Resist-dyeing also works well. Small objects such as beads, buttons and washers can be tied into fabric before mordanting and left in position until the dyeing process is complete. The ties should not be undone until after the fabric has been washed and dried. (Using synthetic thread, which will not take up the dye, makes it easier to see and remove the ties.)

As well as 'tie-dyeing', techniques using stitched resists, such as gathering, also produce good results. Simply knotting threads or yarn in a few places will block both the mordant and the dye, and produce variations of shade which, of course, will include white if the knots are really tight. Some of the dye will penetrate the edges of the knot making attractive gradations of colour.

Machine-stitch before starting the dyeing process

This is useful for embroiderers who like working in monochrome. Carry out decorative machine-stitching with undyed cotton, silk or rayon thread before dyeing. The stitches will take up the dye differently and reveal the design or pattern when dyeing is complete.

Mix dyestuffs, dyes or exhausts to create new shades

Anything can be mixed with anything else, at any stage. For example, I have obtained really interesting and worthwhile results from mixing dyestuffs that had been dried out for reuse. There are endless possibilities for creating exciting new colours in this way.

Use exhaust dyes for papermaking

For those who enjoy making their own paper, a pan of exhaust dye, which is totally spent, has a further use. Substituted for the water in a recipe, it will add subtle colour to paper pulp. The inclusion of a pressed leaf, a few petals or a light sprinkling of the dyestuff itself, makes a sheet of handmade paper extra special.

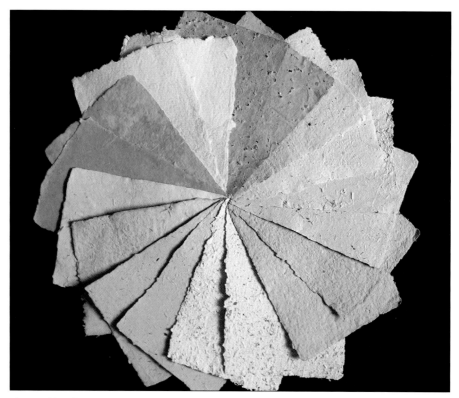

Sheets of handmade paper. Spent exhaust dyes were substituted for the water used to make and suspend the pulp.

WORKING WITH VAT DYES

There are only two dyes that are guaranteed to produce clear, strong blues – indigo and woad. Indigo produces darker shades than woad because it contains a greater concentration of *indican*, the colouring substance common to both. These traditional dyes exceed all others in terms of light and wash fastness. The predominantly blue tapestries that can be seen in many stately homes and castles testify to this: the original greens of trees and plants have changed colour as the yellow dyes have faded leaving the blues to dominate.

Both indigo and woad are substantive dyes requiring no mordant and a completely different dyeing process. The dye is not extracted by simmering but by fermentation in an alkaline vat. The *indican* is insoluble. The fermentation process converts it to a

soluble form *indoxyl*, which can then penetrate the fibres. This involves removing the oxygen from the vat before the fibres are immersed using a 'reducing agent'. When the fibres are removed from the vat, the oxygen in the air fixes the dye by returning it to an insoluble state, *indigotin*, so that it bonds permanently with the fibres. Preparing and using a vat dye needs time and care but it is not difficult. Once the vat is ready to use, dyeing with indigo and woad is both easy and exciting.

I find it best to set aside a block of time for working with these dyes, about half a working day, and to work outside if possible. Indigo powder is very clinging and stains are difficult to remove; drips from the vat will wipe off non-absorbent surfaces if this is done without too much delay, but they will cause permanent staining on fabrics. If it is necessary to work indoors, cover all surfaces, including yourself!

Dyeing with indigo

Powdered indigo is available from dyestuff suppliers by mail order, usually in both 'natural' and 'synthetic' forms. It is important to recognise that the chemical composition of both is the same and not to be misled by the label 'synthetic'. Natural indigo contains impurities which often create variations in colour. If variety is looked for, this is a good reason to choose the natural form. Synthetic indigo, on the other hand, contains no impurities, making it stronger and requiring less to be used. Synthetic indigo is also considerably cheaper to buy. I like the less predictable quality of natural indigo but I also appreciate the economy and uniform results of the synthetic form. The process is exactly the same for both; the choice is entirely a matter of preference.

To make an indigo vat to dye at least 400g (1lb) fibres you will need:

a. Equipment: a plastic bucket with lid, small heatproof bowl, scales, heatproof measuring jug, thermometer, protective clothing, gloves (surgical and long-sleeved);
b. 10g (½oz or 2 teaspoons) natural indigo or 5g (¼oz or 1 teaspoon) synthetic;
c. 50g (2oz) washing soda;
d. 25g (1oz) reducing agent (sodium dithionite, 'spectralite' or colour-run remover. Colour-run remover is available from shops; sodium dithionite and 'spectralite' from mail order dye suppliers); and
e. Natural fibres – protein or cellulose.

The process:

a. Make an alkaline solution. Dissolve the washing soda in about 250ml (9fl.oz) of boiling water in a heatproof jug, stirring all the time.
b. Mix the indigo powder to a paste. Wear surgical gloves and use a small, stainless steel spoon to mix the powder to a smooth paste with about 30ml (1fl.oz) of warm water in a heat-proof bowl.
c. Prepare the indigo solution. Add the washing soda solution slowly to the indigo paste, stirring carefully until dissolved.

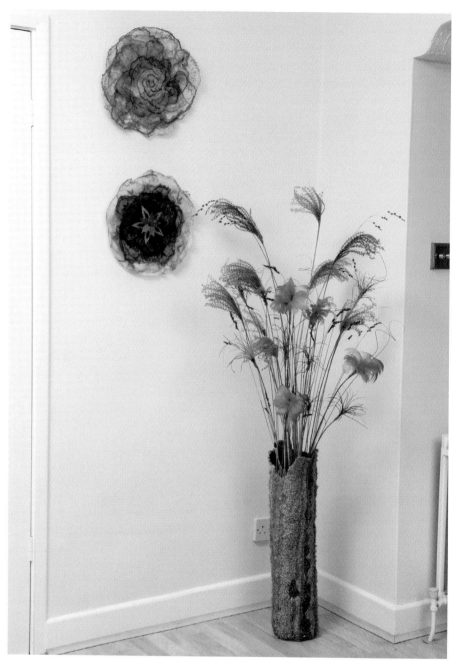

Knitted and woven vase, 67 x 50cm (26 x 19½ in.). This piece of work was inspired by a magazine photograph of the bark of the American black walnut tree. I dyed paper string in an indigo vat before knitting it into long, thin strips using large pins. The strips were woven lengthwise with assorted yarns and fabrics that had also been dyed with indigo, and then stitched together to form a 'trunk'. The base was constructed by circular weaving into a 'spider's web' of paper string. I stiffened the vase from the inside with fabric hardener. The dried grasses and swan-feather flowers were also dipped into the indigo vat. Photo – Steve Walton.

d. Make the indigo vat. Put 4 litres (8 pints) of water, at a temperature of 50°C (120°F), into a plastic bucket or large stainless steel dyepan. The temperature should at no point exceed 60°C (140°F) because this will impair the colour. Add the indigo solution carefully, lowering the bowl into the water so that none of the dye is lost. Stir gently.

e. Remove the oxygen by adding the reducing agent. Sprinkle 25g (1oz) of reducing agent over the surface of the vat. Cover and leave for 30-60 minutes. Try to maintain the temperature of the vat by standing it in a warm place or by wrapping in an old towel. During this time, the colour of the liquid will change from blue to yellow/green. There will be a blue/bronze film on the surface, known as the 'flower', which occurs because it is still in contact with oxygen in the air; it can be removed with a pad of kitchen towel.

f. Dye the fibres. Squeeze the wetted fabric or yarn thoroughly to avoid the introduction of air into the vat. Immerse gently into the vat and leave completely submerged for two to five minutes, depending on the depth of colour required. Any fibres which are not completely below the surface, will have blotches.

g. Fix the dye. Lift out the fibres gently. Try not to let drips fall back into the vat; it helps to leave a 'tail' in the liquid briefly, so that the dye can run back smoothly without disturbing the surface. Expose the fibres fully to the air and watch the colour change in just a few minutes from yellow/green to clear blue. The dipping and airing process can be repeated if darker shades are required. After the final airing, the fibres should be rinsed until the water runs clear, and then washed, rinsed and dried as usual.

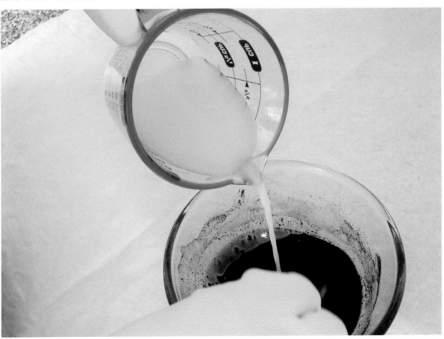

Stirring the washing soda solution into the indigo paste.

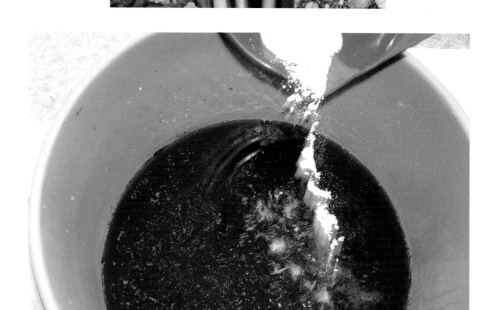

Sprinkling reducing agent over the surface of the vat.

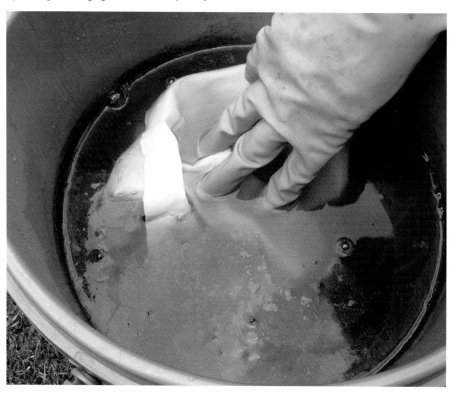

Immersing fabric into the vat. Some of the bronze 'flower' is clearly visible.

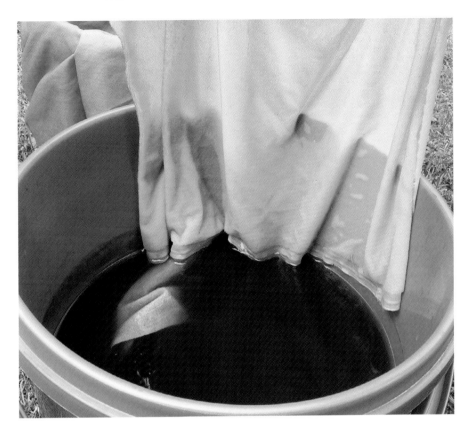

Removing fabric from the indigo vat.

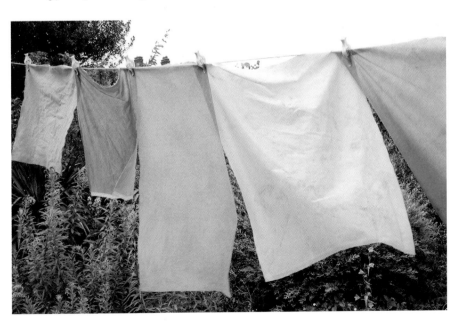

Indigo-dyed fabrics oxidising on the line.

Dyeing with woad

In order to have woad available for dyeing it is necessary to sow some seeds because the clear blue dye is produced only from the fresh leaves of the first season's growth and these are not suitable for freezing or drying. It is possible to pick leaves through the winter and into the early spring, before the flower shoots appear, but the later they are harvested, the less blue is likely to be obtained. As with all natural dyes, there are variables that may, for example, produce a really good blue in December. I have also obtained soft lavender shades from tatty leaves harvested in April, just as the flower spikes started to form. However, for the clearest and brightest blues, harvest the leaves no later than early autumn.

Woad is a very easy plant to grow. Seeds sown in October can usually be cropped from the following June and those sown in spring will be ready later in the year. Sow in shallow drills and thin the seedlings to about six inches apart. Woad likes rich soil and thrives on generous quantities of home made compost, in sun or part shade. It is a biennial and a member of the *brassica* family. A few plants left in the ground over winter will produce attractive yellow flowers followed by clusters of dark, glossy seeds which remain viable for up to five years if dried thoroughly and stored in a paper bag. Seeds can also be obtained from specialist nurseries, or from other dyers who are likely to have a continuous supply.

Dyeing with woad involves the same principles as working with indigo but, because you are using fresh material, the initial process is different.

To make a woad vat to dye 100g (4oz) fibres you will need:

a. Equipment: A plastic bucket with lid, stainless steel dyepan, strainer, hand whisk, scales, thermometer, measuring jug and spoons.

b. 400g (1lb) of fresh leaves. (More leaves will give a stronger colour and allow more fibres to be dyed.)

c. 16g (1 tablespoon) washing soda.

d. 4g (1 level teaspoon) reducing agent (sodium dithionite, 'spectralite' or colour run remover.)

e. 2-3 litres (4-6 pints) soft water (bottled or clean rainwater).

f. 100g (4oz) natural fibres – protein or cellulose.

Woad plants in summer.

Woad seeds ready for harvesting.

Woad leaves in the pan.

The process:

a. Extract the dye. Tear the leaves into small pieces and cover with almost-boiling soft water in a plastic bucket or dyepan. Cover and soak for 30 minutes and then strain off the sherry-coloured liquid. Squeeze the leaves as tightly as possible to extract all the dye and set them aside; they can be used again later to produce an entirely different colour.

b. Make the woad vat. Add the washing soda to the strained liquid, which will make it dark green in colour. Aerate this mixture by whisking vigorously until the froth has turned blue and is beginning to turn green again, indicating that the maximum amount of blue dye has been extracted. This part of the process can take up to ten minutes and is a job best shared!

c. Remove the oxygen by adding the reducing agent. Check the temperature of the liquid and, if necessary, heat in the dyepan to 50°C (120°F). Sprinkle the reducing agent carefully over the surface of the vat. Do not be tempted to stir or disturb the surface at all. Cover and leave to stand in a warm place for about ten minutes.

d. Dye the fibres. Immerse the wetted fibres gradually. Try to avoid introducing air into the vat. Ensure that all materials are completely submerged and then leave to soak for 15-20 minutes.

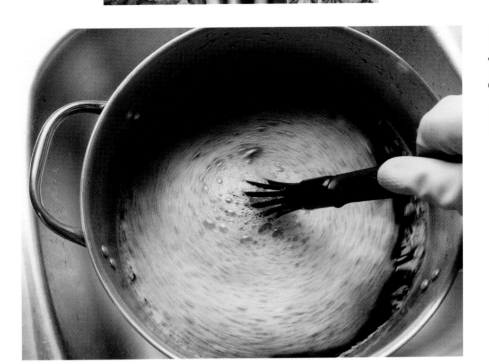

Whisking the woad vat.

Immersing fabric into the woad vat.

e. Fix the dye. Remove the fibres very carefully without allowing the liquid to drip back into the vat. Expose the fibres to the air until the colour has progressed from yellow through green to clear blue. Repeat the dipping and airing process until the depth of colour is what you want or the vat is exhausted. After the final airing, rinse thoroughly, wash and dry as usual.

Colours move from yellow to green when the fibres are removed from the woad vat

When all the green has turned to blue, the airing process is complete and the dye is fixed.

Woad pink

This is a real bonus when working with woad. Use the squeezed leaves that you remembered to keep and follow the standard process described at the start of this chapter. Simmer the leaves for about 30 minutes before straining off the liquid and adding some alum-mordanted fabric or threads. The colour achieved will vary between tan and soft pink. It can be susceptible to fading but is always worth the experiment.

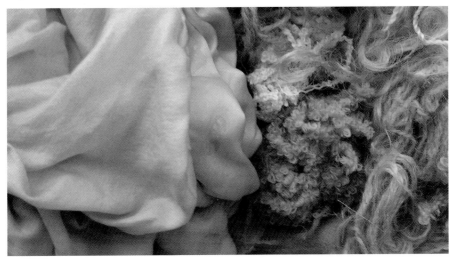

Woad blue and woad pink obtained from the same leaves.

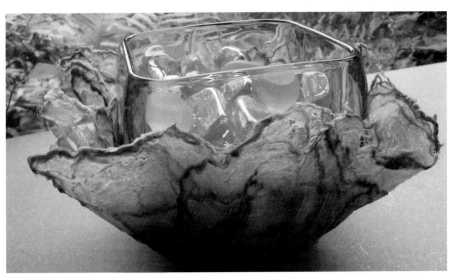

Silk bowl. 18 x 18 x 10cm (7 x 7 x 4in.). Dyed with woad. The gossamer layers of a dyed silk 'hankie' were stitched between two pieces of transparent aquafilm (soluble fabric). The aquafilm was dissolved away and the wet silk draped over a square former before being dried and stiffened. This is a quick and easy way to make delicate silk vessels.

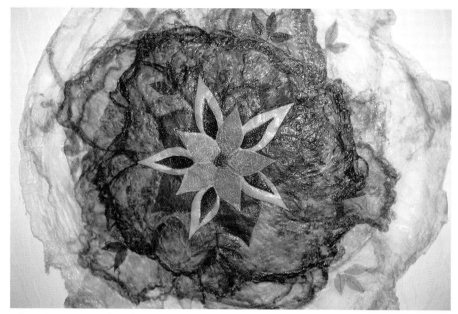

Silk wall plate. 36cm (14in.) diam. – dyed with indigo (dark/mid-blue) and woad (pale blue). Layers of silk 'hankies' were pinned between two pieces of aquafilm with the darkest shades at the centre. Small leaves and petals, cut from assorted scraps of dyed silk, were arranged on top and running-stitched into position. A cluster of french knots made the centre. The aquafilm was dissolved away and the plate shaped over a circular tray covered in clingfilm. After drying, it was stiffened on both sides.

Disposing of an indigo or woad vat

To exhaust a vat completely, immerse a piece of cotton and leave overnight. An old bath towel is ideal and can be used repeatedly for this purpose. The following day, remove the towel and whisk the dyebath to incorporate air and use up any remaining reducing agent. The vat can then be disposed of safely by pouring down the lavatory.

Overdyeing

Before disposing of an indigo or woad vat, consider that you might want to use it to overdye yellow to produce green.

'Overdyeing' simply means dyeing the same fibres more than once, using at least two different dyes. In the case of natural dyes, it is used most often to obtain good, clear greens by overdyeing yellow with blue. This usually means dyeing the fibres yellow by using the standard process and then dipping them into an indigo or woad vat. The fibres can be dipped and aired repeatedly until the desired shade is achieved. Dyeing the lighter colour first allows more control over the outcome: there is a limit to the extent to which deep blue shades can be moved towards yellow but the same does not apply to moving yellow towards blue.

It is important to remember that dyeing the fibre yellow will require the use of a mordant even though dyeing with indigo or woad alone does not. This is to prevent the yellow from gradually fading and leaving the blue to dominate.

Another way of obtaining good green shades, after first dyeing the fibres yellow, is to overdye by simmering for 15-30 minutes in a spent logwood dyebath. Fustic, weld, turmeric and onion skins all produce beautiful green shades when overdyed with indigo, woad or logwood.

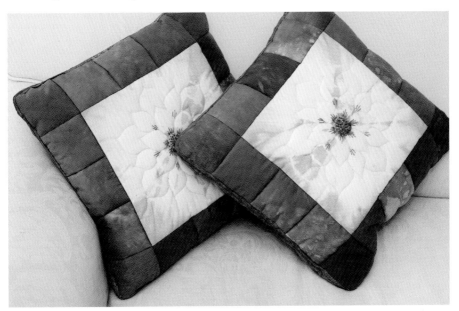

Patchwork cushions. 36 x 36cm (14 x 14in.). The cotton, centre panels were dyed with turmeric before being tie-dyed with woad; the smaller, outer squares of assorted fabrics were dyed with indigo and then simmered in turmeric. Photo – Steve Walton.

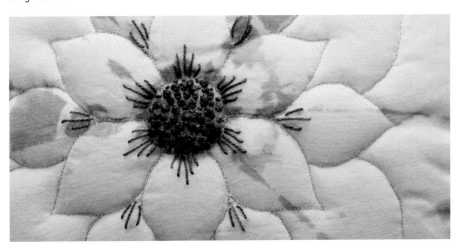

The centre panels were machine-quilted and hand-stitched with cotton perlé. Photo – Steve Walton.

Useful tips – and a few other suggestions

Dip wool or silk fibres into the indigo vat before dipping cotton

The best results on wool and silk are produced when the vat is warm, close to 50°C (120°F). Cotton takes the dye best when the vat is cooler, about 30°C (85°F).

Use vat dyes to colour a range of natural objects

Because vat dyeing involves dipping instead of stirring, it is suitable for very delicate things like dried grasses and feathers. It also works well on pieces of driftwood, dried seedheads and wooden beads.

Use indigo or woad for any form of resist dyeing

Indigo is the traditional dye used for batik work when liquid wax is applied as a design with a tool called a *tjanting*, a 'pen' with a narrow tube for a nib and a well for holding the liquid batik wax.

Candlewax, beeswax, crayons, oilsticks and flour paste can all be used to make marks on fabric that will prevent the dye from attaching to the fibres.

Indigo is also the dye used in 'shibori', a technique of Japanese origin involving the use of running stitches to gather fabric and form a barrier to the dye.

Overdye previously resist-dyed pieces

Using fabric that has already been resist-patterned with a different colour, additional patterns and new shades can be obtained by dipping into a vat dye. Leave the original resist in place, e.g. ties or stitches, if you want to include white in the final design. Apply a second resist to create more pattern and then dip into the vat to add blue. All of the ties or stitching should be left in place until the fabric has been washed and dried.

Use almost-exhausted vats for patchy overdyeing

This applies particularly to woad, which exhausts quicker than indigo. When results become patchy and you are tempted to dispose of the vat, immerse a small quantity of fabric, yarn or threads of a paler colour and enjoy the variations that emerge. The fabrics and threads on the 'Turmeric and Woad' sample board in Chapter 4 were obtained in this way.

Health and Safety

Most of the requirements for the safe practice of natural dyeing are a matter of common sense. That being said, incorporating the points made below into your routine, will ensure that your experience of working with these wonderful colours is not only exciting and rewarding, but also safe. These precautions take very little extra time or trouble, and if you acquire good dyeing habits from the outset then they will soon become second nature.

- **Store all materials in labelled, sealed containers** – away from children and the food cupboard. A high shelf in a cool, dark place is ideal.

- **Keep dyeing equipment exclusively for that purpose** – even when you are working with vegetables, fruit or spices, because you will probably put mordanted fibres into the pan. Any kitchen equipment used for dyeing purposes should not be used again in the preparation of food.

- **Follow instructions exactly** – if these are supplied with bought dyestuffs or mordants. Where there are no instructions, take particular care with chemical substances by measuring out carefully and not exceeding the quantities recommended in this book.

- **Handle all chemicals with care** – bearing in mind that some dyestuffs, as well as mordants, may be toxic.

- **Always wear gloves** – preferably surgical ones for weighing powders and long-sleeved gauntlets for working with indigo and woad. Household gloves are fine for everything else.

- **Use a face-mask** – to avoid inhaling fine powders.

- **Wear protective clothing** – because splashes are inevitable and likely to be permanent.

- **Put nothing in your mouth while working with dyes** – unless you first remove your gloves, wash your hands thoroughly and move away from the work area.

- **Always add acids to water; never add water to acid** – this is to avoid creating toxic fumes or, in the case of the reducing agents needed in vat dyeing, to prevent possible spontaneous combustion. Make sure that the measuring spoon is kept dry and the chemical is covered while you work to avoid contact with drips and splashes.

- **Do not exceed simmering point when mordanting** – keep the lid on the pan to contain fumes.

- **Keep the work area well ventilated** – for both health and comfort. An extractor fan is useful for taking away any vapours from mordant pans and for making the area more pleasant when simmering the more pungent dyestuffs.

- **Ensure that all chemicals are fully used up before disposal** – mordant baths should be reused until no longer effective; this is generally indicated by the absence of smell which occurs after being used several times. Dilute with plenty of water and dispose of down the lavatory, not down the sink.

CHAPTER FOUR

Sample Boards

It was not long after producing the first samples of natural-dyed fabrics and threads that I realised the need for a system of record keeping. I also recognised the possibility of losing interest in knotting bits of thread onto cards, labelling these and maintaining a systematic storage system! I wanted a way of keeping comprehensive records that would be interesting and attractive in their own right and thought of compiling a book, each page featuring one source of dye. However, after putting together the 'page' on blackberries, I realised that this was not a viable option because the pages were too large and heavy and, in any case, would not be enhanced by having holes punched in them. This was how the collection of 'sample boards' came into being.

Each board comprises a sample of 'cushion stitch' on 16-count canvas, using contrasting threads, and small swatches of various fabrics, labelled to show the mordant used, the type of fabric and any other significant variations. Small pieces of creative work have been added for extra interest. The samples are mounted into a frame of watercolour paper which has been painted with the spent dye liquid (the 'exhaust') and, where possible, printed or textured using the original dye material. This format allows enough space to add a brief description and account of any special features of working with that particular source of colour.

It is worth emphasising here that the results shown on each sample board are those achieved on one occasion using one particular batch of dyestuff. It is possible, or even likely, that on another occasion, using the 'same' ingredients and the same method, the results would be significantly different. A couple of years ago, a friend was much taken with the soft pinks of the sanderswood samples and asked me to make a wall hanging. I bought the sanderswood chips from the original supplier and followed the same recipe as before. The result – a metre of silk organza in a beautiful shade of orange! Fortunately, I had dried the used chips from the first experiment for possible reuse and they produced the required shades. This little anecdote is included to make the point that your results may not be the same as mine. The time of year, the acidity of the soil, the softness of the water and other variables will make a difference to the outcome, and this can just as easily apply to dried dyestuffs purchased by mail order.

The sample boards give a general idea of the colours that can be produced and the effects of using different mordants or processes. The additional comments make particular points about the use of each source of dye.

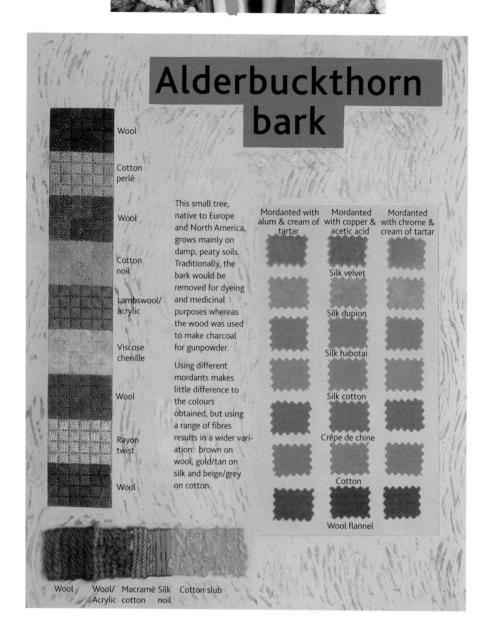

Alderbuckthorn bark

Wool

Cotton perlé

Wool

Cotton noil

Lambswool/ acrylic

Viscose chenille

Wool

Rayon twist

Wool

This small tree, native to Europe and North America, grows mainly on damp, peaty soils. Traditionally, the bark would be removed for dyeing and medicinal purposes whereas the wood was used to make charcoal for gunpowder.

Using different mordants makes little difference to the colours obtained, but using a range of fibres results in a wider variation: brown on wool, gold/tan on silk and beige/grey on cotton.

	Mordanted with alum & cream of tartar	Mordanted with copper & acetic acid	Mordanted with chrome & cream of tartar
Silk velvet			
Silk dupion			
Silk habotai			
Silk cotton			
Crêpe de chine			
Cotton			
Wool flannel			

Wool Wool/ Macramé Silk Cotton slub
 Acrylic cotton noil

Alderbuckthorn bark. *Rhamnus fangula* Europe, N.America.

Comments: Place bark chips in hot water and soak overnight before using. To obtain a range of shades, use alum as a mordant and a variety of fibres. This dye has good light and wash fastness. *Photo – Steve Walton*.

44

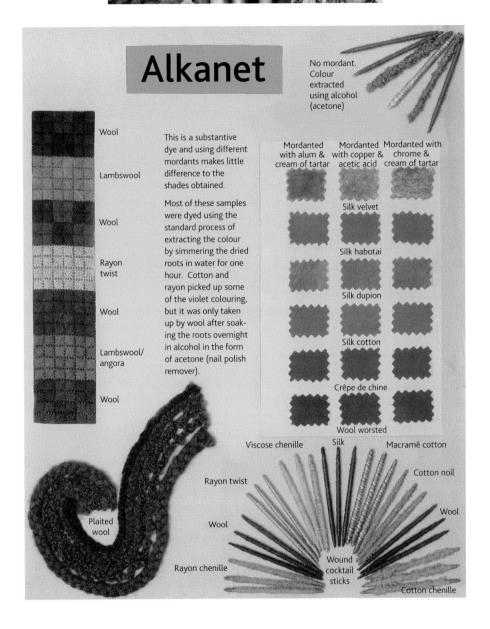

Alkanet

No mordant. Colour extracted using alcohol (acetone)

Wool

Lambswool

Wool

Rayon twist

Wool

Lambswool/ angora

Wool

This is a substantive dye and using different mordants makes little difference to the shades obtained.

Most of these samples were dyed using the standard process of extracting the colour by simmering the dried roots in water for one hour. Cotton and rayon picked up some of the violet colouring, but it was only taken up by wool after soaking the roots overnight in alcohol in the form of acetone (nail polish remover).

Mordanted with alum & cream of tartar	Mordanted with copper & acetic acid	Mordanted with chrome & cream of tartar

Silk velvet

Silk habotai

Silk dupion

Silk cotton

Crêpe de chine

Wool worsted

Viscose chenille

Silk

Macramê cotton

Cotton noil

Rayon twist

Wool

Plaited wool

Wool

Rayon chenille

Wound cocktail sticks

Cotton chenille

Alkanet. *Alkanna tinctoria* S.Europe, Africa, Asia Minor, M.East.

Comments: It is advisable to buy alkanet as chopped, dried roots to avoid confusion with *anchusa* and other borage-related garden plants. The standard process produces soft violet, green/grey and silver shades. Soaking the roots in alcohol (nail-polish remover) releases more of the dye substance *alkanna* and moves the greys towards violet. *Photo – Steve Walton.*

45

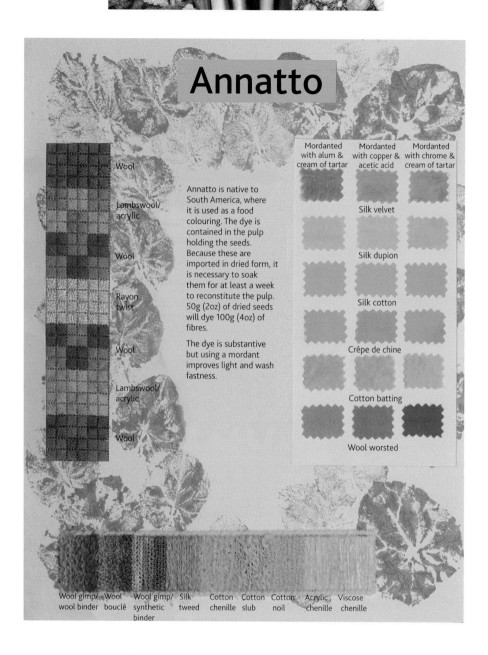

Annatto

Annatto is native to South America, where it is used as a food colouring. The dye is contained in the pulp holding the seeds. Because these are imported in dried form, it is necessary to soak them for at least a week to reconstitute the pulp. 50g (2oz) of dried seeds will dye 100g (4oz) of fibres.

The dye is substantive but using a mordant improves light and wash fastness.

Wool

Lambswool/acrylic

Wool

Rayon twist

Wool

Lambswool/acrylic

Wool

	Mordanted with alum & cream of tartar	Mordanted with copper & acetic acid	Mordanted with chrome & cream of tartar
Silk velvet			
Silk dupion			
Silk cotton			
Crêpe de chine			
Cotton batting			
Wool worsted			

Wool gimp/wool binder · Wool bouclé · Wool gimp/synthetic binder · Silk tweed · Cotton chenille · Cotton slub · Cotton noil · Acrylic chenille · Viscose chenille

Annatto. (Lipstick plant) *Bixa orellana* S.America.

Comments: Soak the seeds for at least a week in 2 litres (4 pints) of water to which has been added ¼ litre (½ pint) of white vinegar. This is to reconstitute the pulp that contains the dye. When the seeds have softened, add a handful of salt and simmer for one hour. Strain the dye and proceed as usual. This dye works well on cotton and other cellulose fibres, without special mordanting. *Photo – Steve Walton.*

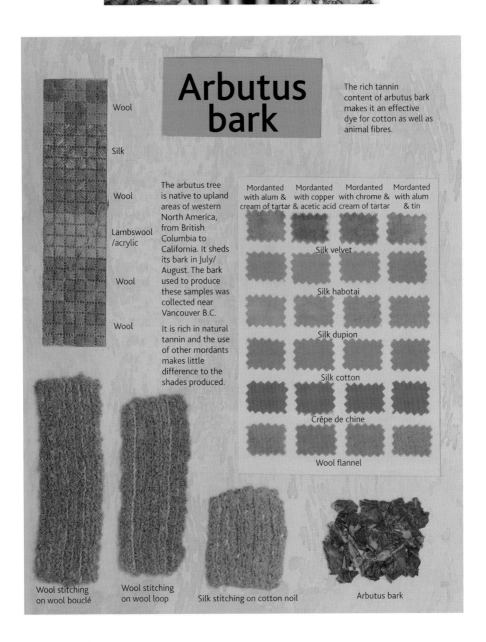

Wool

Silk

Wool

Lambswool /acrylic

Wool

Wool

Arbutus bark

The rich tannin content of arbutus bark makes it an effective dye for cotton as well as animal fibres.

The arbutus tree is native to upland areas of western North America, from British Columbia to California. It sheds its bark in July/ August. The bark used to produce these samples was collected near Vancouver B.C.

It is rich in natural tannin and the use of other mordants makes little difference to the shades produced.

Mordanted with alum & cream of tartar	Mordanted with copper & acetic acid	Mordanted with chrome & cream of tartar	Mordanted with alum & tin

Silk velvet

Silk habotai

Silk dupion

Silk cotton

Crêpe de chine

Wool flannel

Wool stitching on wool bouclé

Wool stitching on wool loop

Silk stitching on cotton noil

Arbutus bark

Arbutus bark. (Madrona) *Arbutus menziesii* N.America.

Comments: This bark is rich in tannin and therefore can be used successfully on all fibres, including cotton, without the use of other mordants. Put in warm water and soak overnight before use. *Photo – Steve Walton.*

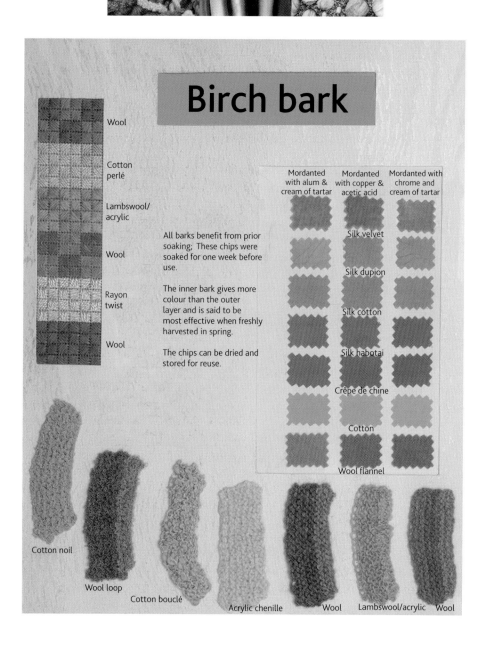

Birch bark

	Mordanted with alum & cream of tartar	Mordanted with copper & acetic acid	Mordanted with chrome and cream of tartar

Wool

Cotton perlé

Lambswool/ acrylic

Wool

Rayon twist

Wool

All barks benefit from prior soaking; These chips were soaked for one week before use.

The inner bark gives more colour than the outer layer and is said to be most effective when freshly harvested in spring.

The chips can be dried and stored for reuse.

Silk velvet

Silk dupion

Silk cotton

Silk habotai

Crêpe de chine

Cotton

Wool flannel

Cotton noil

Wool loop

Cotton bouclé

Acrylic chenille Wool Lambswool/acrylic Wool

Birch bark. *Betula* species

Comments: The best shades are obtained from the inner bark, not the papery, outer layer. Soak the chips for a few days before using. *Photo – Steve Walton*.

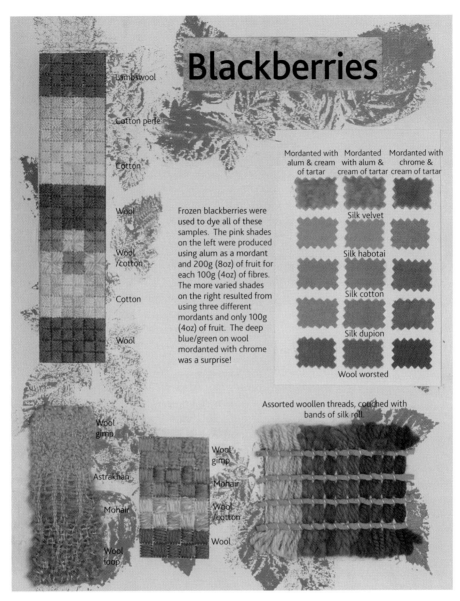

Blackberries

Lambswool

Cotton perle

Cotton

Wool

Wool /cotton

Cotton

Wool

	Mordanted with alum & cream of tartar	Mordanted with alum & cream of tartar	Mordanted with chrome & cream of tartar
Silk velvet			
Silk habotai			
Silk cotton			
Silk dupion			
Wool worsted			

Frozen blackberries were used to dye all of these samples. The pink shades on the left were produced using alum as a mordant and 200g (8oz) of fruit for each 100g (4oz) of fibres. The more varied shades on the right resulted from using three different mordants and only 100g (4oz) of fruit. The deep blue/green on wool mordanted with chrome was a surprise!

Assorted woollen threads, couched with bands of silk roll.

Wool gimp

Astrakhan

Mohair

Wool loop

Wool gimp

Mohair

Wool /cotton

Wool

Blackberries. *Rubus fruticosa*

Comments: Fruit can be used fresh or frozen with the same results. For maximum colour yield, fresh berries should be crushed before use. One of the simplest dyestuffs to work with, blackberries produce a deep purple dye after only a short simmer. All berry dyes are inclined to fade a little, but the duskier shades that result are still worth the effort and they do stabilise with time.
Photo – Steve Walton.

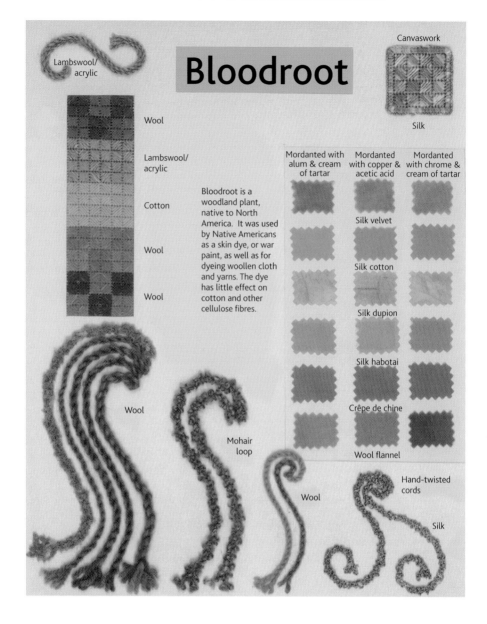

Bloodroot

Lambswool/acrylic

Canvaswork

Wool

Silk

Lambswool/acrylic

Cotton

Wool

Wool

Bloodroot is a woodland plant, native to North America. It was used by Native Americans as a skin dye, or war paint, as well as for dyeing woollen cloth and yarns. The dye has little effect on cotton and other cellulose fibres.

	Mordanted with alum & cream of tartar	Mordanted with copper & acetic acid	Mordanted with chrome & cream of tartar
Silk velvet			
Silk cotton			
Silk dupion			
Silk habotai			
Crêpe de chine			
Wool flannel			

Wool

Mohair loop

Wool

Hand-twisted cords

Silk

Bloodroot. *Sanguinaria canadensis.* N.America.

Comments: Roots are purchased chopped and dried. They should be pounded and soaked in water for a few days before using. *Photo – Steve Walton.*

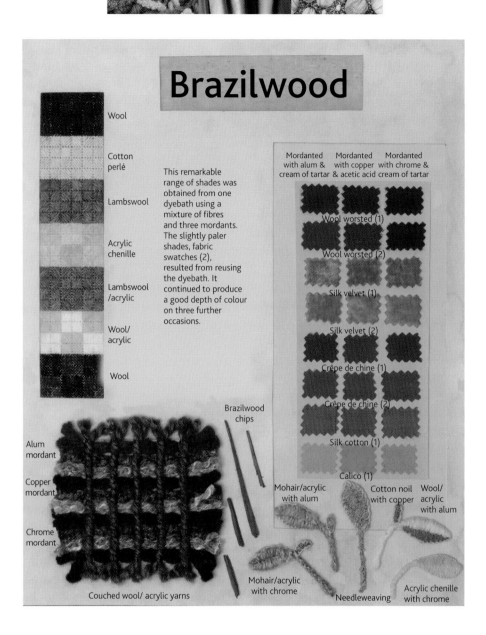

Brazilwood

Wool

Cotton perlé

Lambswool

This remarkable range of shades was obtained from one dyebath using a mixture of fibres and three mordants. The slightly paler shades, fabric swatches (2), resulted from reusing the dyebath. It continued to produce a good depth of colour on three further occasions.

Acrylic chenille

Lambswool /acrylic

Wool/ acrylic

Wool

	Mordanted with alum & cream of tartar	Mordanted with copper & acetic acid	Mordanted with chrome & cream of tartar
Wool worsted (1)			
Wool worsted (2)			
Silk velvet (1)			
Silk velvet (2)			
Crêpe de chine (1)			
Crêpe de chine (2)			
Silk cotton (1)			
Calico (1)			

Brazilwood chips

Alum mordant

Copper mordant

Chrome mordant

Couched wool/ acrylic yarns

Mohair/acrylic with alum

Mohair/acrylic with chrome

Cotton noil with copper

Needleweaving

Wool/ acrylic with alum

Acrylic chenille with chrome

Brazilwood. *Caesalpinia echinata* Indonesia, S.America.

Comments: These heartwood chips should be soaked for at least two days before use. An extraordinary range of shades is achieved by using a variety of fibres but the lovely clear reds are obtained only on wool. *Photo – Steve Walton.*

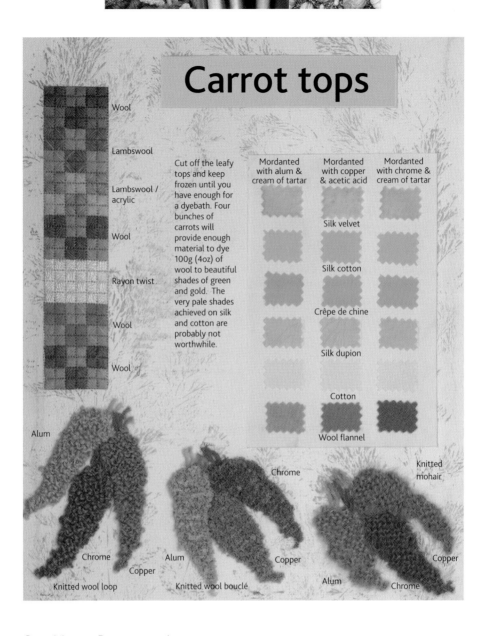

Carrot tops

Wool				
Lambswool				
Lambswool / acrylic	Cut off the leafy tops and keep frozen until you have enough for a dyebath. Four bunches of carrots will provide enough material to dye 100g (4oz) of wool to beautiful shades of green and gold. The very pale shades achieved on silk and cotton are probably not worthwhile.	Mordanted with alum & cream of tartar	Mordanted with copper & acetic acid	Mordanted with chrome & cream of tartar
Wool		Silk velvet		
Rayon twist		Silk cotton		
Wool		Crêpe de chine		
Wool		Silk dupion		
		Cotton		
Alum		Wool flannel		

Chrome

Knitted mohair

Chrome

Copper

Copper

Chrome

Copper

Alum

Knitted wool loop

Alum

Knitted wool bouclé

Chrome

Carrot tops. *Daucus carota*

Comments: These leaves produce a good depth of colour on wool but have little effect on other fibres. To achieve a range of shades, including green, use different mordants. *Photo – Steve Walton.*

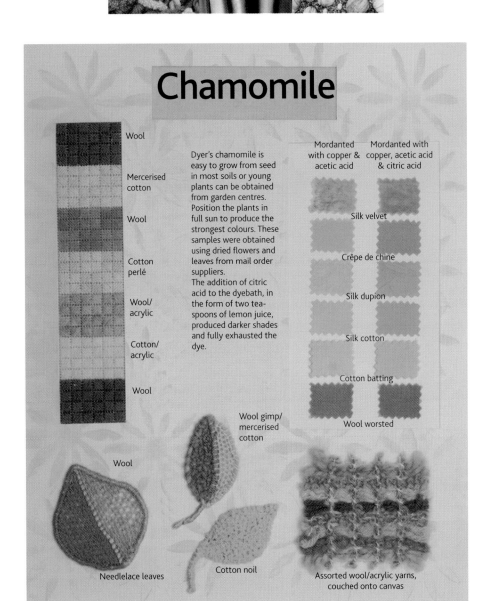

Chamomile

Wool

Mercerised cotton

Wool

Cotton perlé

Wool/acrylic

Cotton/acrylic

Wool

Dyer's chamomile is easy to grow from seed in most soils or young plants can be obtained from garden centres. Position the plants in full sun to produce the strongest colours. These samples were obtained using dried flowers and leaves from mail order suppliers.

The addition of citric acid to the dyebath, in the form of two tea-spoons of lemon juice, produced darker shades and fully exhausted the dye.

Mordanted with copper & acetic acid	Mordanted with copper, acetic acid & citric acid

Silk velvet

Crêpe de chine

Silk dupion

Silk cotton

Cotton batting

Wool worsted

Wool gimp/mercerised cotton

Wool

Needlelace leaves

Cotton noil

Assorted wool/acrylic yarns, couched onto canvas

Chamomile. *Anthemis tinctoria*

Comments: Fibres mordanted with alum are inclined to fade. Use copper as a mordant and, if working with fresh material, try separating flowers and leaves to achieve both gold and green shades. *Photo – Steve Walton.*

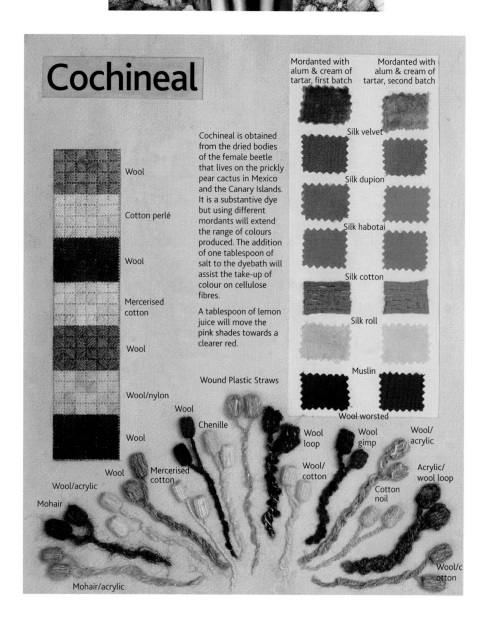

Cochineal

Cochineal is obtained from the dried bodies of the female beetle that lives on the prickly pear cactus in Mexico and the Canary Islands. It is a substantive dye but using different mordants will extend the range of colours produced. The addition of one tablespoon of salt to the dyebath will assist the take-up of colour on cellulose fibres.

A tablespoon of lemon juice will move the pink shades towards a clearer red.

Mordanted with alum & cream of tartar, first batch | Mordanted with alum & cream of tartar, second batch

Wool
Cotton perlé
Wool
Mercerised cotton
Wool
Wool/nylon
Wool
Wool
Wool
Mercerised cotton
Wool/acrylic
Mohair
Mohair/acrylic

Silk velvet
Silk dupion
Silk habotai
Silk cotton
Silk roll
Muslin
Wool worsted

Wound Plastic Straws
Wool
Chenille

Wool loop
Wool gimp
Wool/acrylic
Wool/cotton
Acrylic/wool loop
Cotton noil
Wool/cotton

Cochineal. *Dactylopius coccus* S.America.

Comments: Cochineal is expensive but a little goes a very long way. 25g (1oz) per 100g (4oz) dry weight of fibres will produce a good depth of colour on wool and silk. To extract the maximum amount of colour, the dried beetles should be ground before making the dyebath. A coffee grinder is ideal; keep it solely for this purpose or wash it very thoroughly after use – unless you like the prospect of pink coffee! The dye liquid can be reused many times producing lovely colours that become slightly paler with each use. *Photo – Steve Walton.*

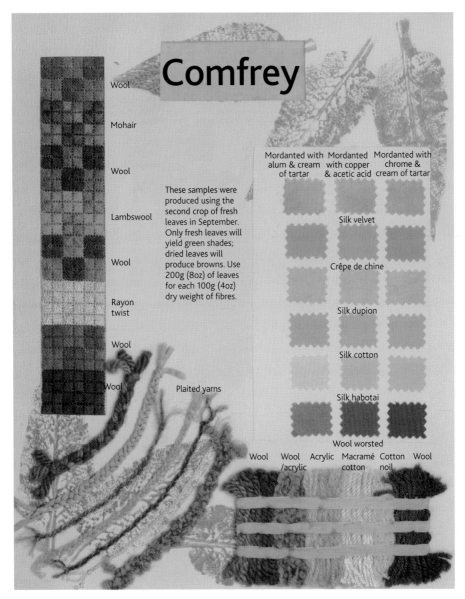

Comfrey

Wool

Mohair

Wool

Lambswool

These samples were produced using the second crop of fresh leaves in September. Only fresh leaves will yield green shades; dried leaves will produce browns. Use 200g (8oz) of leaves for each 100g (4oz) dry weight of fibres.

Wool

Rayon twist

Wool

Wool

Plaited yarns

	Mordanted with alum & cream of tartar	Mordanted with copper & acetic acid	Mordanted with chrome & cream of tartar
Silk velvet			
Crêpe de chine			
Silk dupion			
Silk cotton			
Silk habotai			
Wool worsted			

Wool	Wool /acrylic	Acrylic	Macramé cotton	Cotton noil	Wool

Comfrey. *Symphytum officinale*

Comments: Fresh leaves need to be chopped and soaked overnight. Comfrey is one of the few garden plants to produce reliable greens; the clearest shades result from using copper as a mordant. *Photo – Steve Walton.*

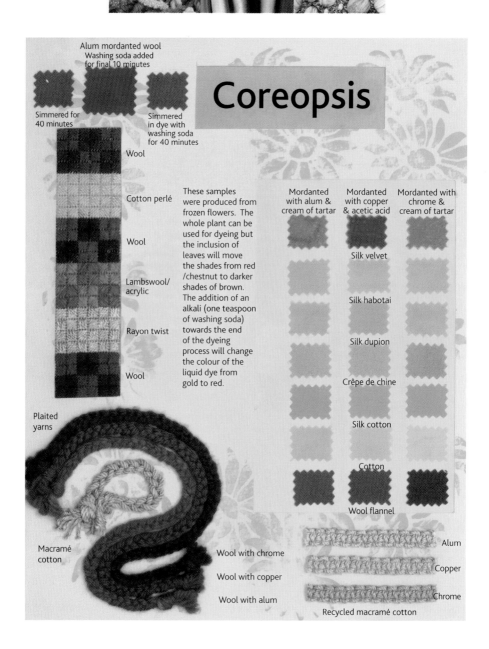

Alum mordanted wool
Washing soda added
for final 10 minutes

Simmered for
40 minutes

Simmered
in dye with
washing soda
for 40 minutes

Coreopsis

Wool

Cotton perlé

Wool

Lambswool/
acrylic

Rayon twist

Wool

Plaited
yarns

Macramé
cotton

These samples were produced from frozen flowers. The whole plant can be used for dyeing but the inclusion of leaves will move the shades from red /chestnut to darker shades of brown. The addition of an alkali (one teaspoon of washing soda) towards the end of the dyeing process will change the colour of the liquid dye from gold to red.

Mordanted with alum & cream of tartar	Mordanted with copper & acetic acid	Mordanted with chrome & cream of tartar
	Silk velvet	
	Silk habotai	
	Silk dupion	
	Crêpe de chine	
	Silk cotton	
	Cotton	
	Wool flannel	

Wool with chrome

Wool with copper

Wool with alum

Alum

Copper

Chrome

Recycled macramé cotton

Coreopsis. *Coreopsis grandiflora*

Comments: Coreopsis is a reliable source of strong colour. Remove the flower heads of garden plants regularly to prolong flowering, and dry or freeze until required. To move the shades towards a clear red, add a teaspoon of washing soda ten minutes before the end of the dyeing process. *Photo – Steve Walton.*

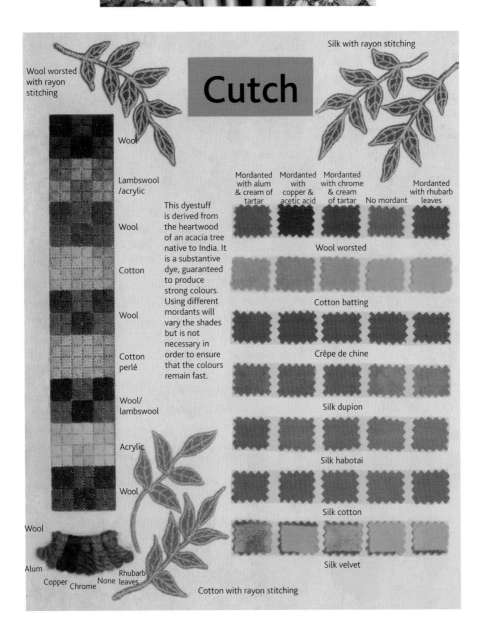

Silk with rayon stitching

Wool worsted with rayon stitching

Cutch

Wool

Lambswool /acrylic

Wool

Cotton

Wool

Cotton perlé

Wool/ lambswool

Acrylic

Wool

This dyestuff is derived from the heartwood of an acacia tree native to India. It is a substantive dye, guaranteed to produce strong colours. Using different mordants will vary the shades but is not necessary in order to ensure that the colours remain fast.

Mordanted with alum & cream of tartar	Mordanted with copper & acetic acid	Mordanted with chrome & cream of tartar	No mordant	Mordanted with rhubarb leaves

Wool worsted

Cotton batting

Crêpe de chine

Silk dupion

Silk habotai

Silk cotton

Silk velvet

Wool

Alum

Copper Chrome None Rhubarb leaves

Cotton with rayon stitching

Cutch. *Acacia catechu* India.

Comments: Cutch is available either as a resin, which needs to be pounded before use, or as a coarse powder which is much easier to process. The strong colours are fixed permanently by oxidation at the rinsing stage. This dye is excellent in terms of light and wash fastness, with or without the use of a mordant.
Photo – Steve Walton.

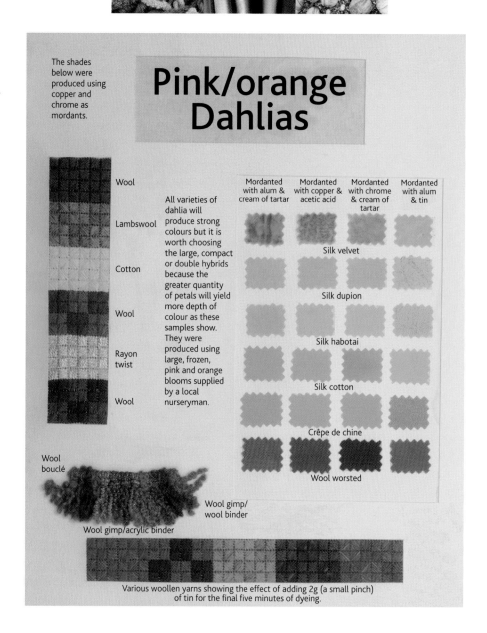

The shades below were produced using copper and chrome as mordants.

Pink/orange Dahlias

	Mordanted with alum & cream of tartar	Mordanted with copper & acetic acid	Mordanted with chrome & cream of tartar	Mordanted with alum & tin
Wool				
Lambswool				
Cotton		Silk velvet		
Wool		Silk dupion		
Rayon twist		Silk habotai		
Wool		Silk cotton		
		Crêpe de chine		
		Wool worsted		

All varieties of dahlia will produce strong colours but it is worth choosing the large, compact or double hybrids because the greater quantity of petals will yield more depth of colour as these samples show. They were produced using large, frozen, pink and orange blooms supplied by a local nurseryman.

Wool bouclé

Wool gimp/acrylic binder

Wool gimp/ wool binder

Various woollen yarns showing the effect of adding 2g (a small pinch) of tin for the final five minutes of dyeing.

Dahlias (pink/orange) *Dahlia* – many hybrids

Comments: Dahlias should be picked just before they start to fade. If they are to be stored in the freezer, wrap securely in several plastic bags to seal in the pungent smell! Simmering the flowers for thirty minutes will extract the dye, leaving the petals almost transparent. The addition of 2g (⅛oz) of tin, towards the end of the dyeing process, makes the colours really vibrant. *Photo – Steve Walton.*

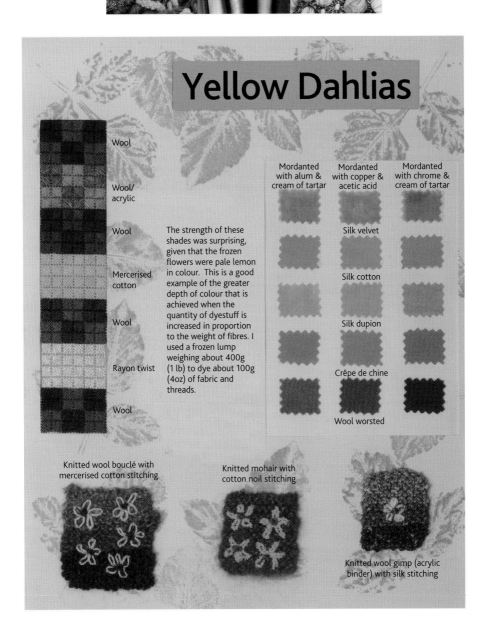

Yellow Dahlias

Wool

Wool/ acrylic

Wool

Mercerised cotton

Wool

Rayon twist

Wool

The strength of these shades was surprising, given that the frozen flowers were pale lemon in colour. This is a good example of the greater depth of colour that is achieved when the quantity of dyestuff is increased in proportion to the weight of fibres. I used a frozen lump weighing about 400g (1 lb) to dye about 100g (4oz) of fabric and threads.

	Mordanted with alum & cream of tartar	Mordanted with copper & acetic acid	Mordanted with chrome & cream of tartar
Silk velvet			
Silk cotton			
Silk dupion			
Crêpe de chine			
Wool worsted			

Knitted wool bouclé with mercerised cotton stitching

Knitted mohair with cotton noil stitching

Knitted wool gimp (acrylic binder) with silk stitching

Dahlias (yellow) *Dahlia* – many hybrids

Comments: All varieties of dahlia produce lovely colours for the dyepot and deciding whether to process different colours separately depends mainly on the quantity of blooms available. The colour of the flowers gives little indication of the outcome of the dyeing process but the results show interesting differences. In addition to the colours shown on these two pages, shades ranging from gold to chestnut brown were obtained from red flowers, and purple blooms produced various tans. *Photo – Steve Walton.*

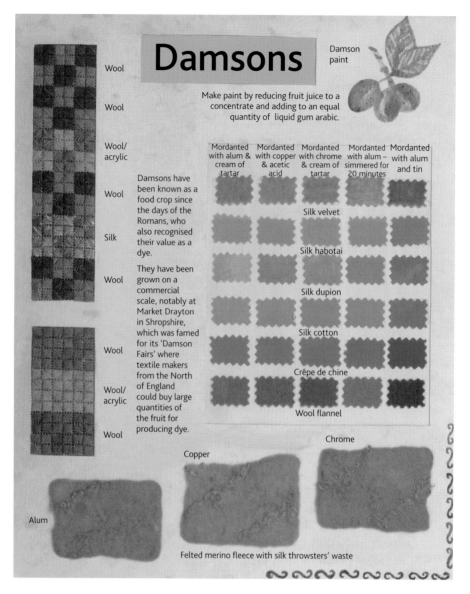

Damsons. *Prunus domestica*

Comments: To obtain the clearest pinks, use an alum mordant and simmer fibres in the dyebath for no more than 20 minutes. If you have surplus fruit, try making damson 'paint'. Simmer fruit slowly without water to produce a liquid concentrate. Allow this to cool and then mix with an equal quantity of liquid gum arabic, available from art shops. This glossy, deep red paint can be used on fabric or paper and stores well in a screw-top jar. *Photo – Steve Walton.*

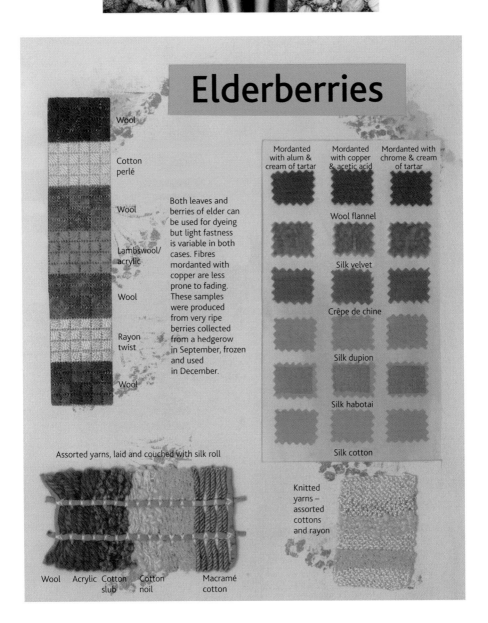

Elderberries

Wool

Cotton perlé

Wool

Lambswool/acrylic

Wool

Rayon twist

Wool

Both leaves and berries of elder can be used for dyeing but light fastness is variable in both cases. Fibres mordanted with copper are less prone to fading. These samples were produced from very ripe berries collected from a hedgerow in September, frozen and used in December.

Mordanted with alum & cream of tartar	Mordanted with copper & acetic acid	Mordanted with chrome & cream of tartar
	Wool flannel	
	Silk velvet	
	Crêpe de chine	
	Silk dupion	
	Silk habotai	
	Silk cotton	

Assorted yarns, laid and couched with silk roll

Knitted yarns – assorted cottons and rayon

Wool Acrylic Cotton slub Cotton noil Macramé cotton

Elderberries. *Sambucus nigra*

Comments: Elderberries can be used fresh, frozen or purchased in dried form, in which case they should be reconstituted by soaking overnight in water before use. Soft pinks and browns are obtained on wool and silk. Cotton, treated in the same way, will provide shades of silver-grey. *Photo – Steve Walton.*

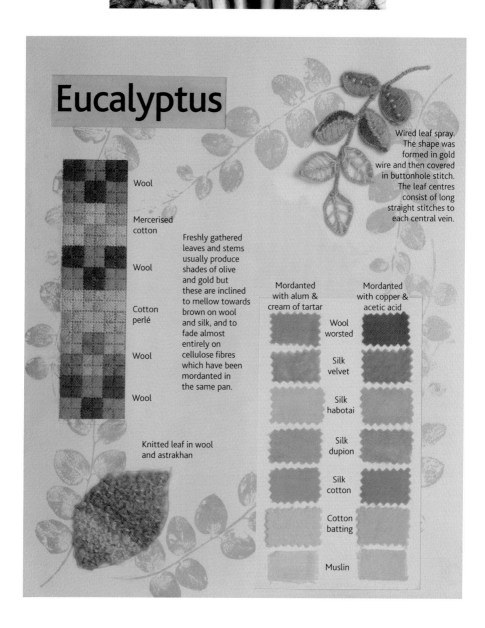

Eucalyptus

Wired leaf spray. The shape was formed in gold wire and then covered in buttonhole stitch. The leaf centres consist of long straight stitches to each central vein.

Wool

Mercerised cotton

Wool

Cotton perlé

Wool

Wool

Knitted leaf in wool and astrakhan

Freshly gathered leaves and stems usually produce shades of olive and gold but these are inclined to mellow towards brown on wool and silk, and to fade almost entirely on cellulose fibres which have been mordanted in the same pan.

	Mordanted with alum & cream of tartar	Mordanted with copper & acetic acid
Wool worsted		
Silk velvet		
Silk habotai		
Silk dupion		
Silk cotton		
Cotton batting		
Muslin		

Eucalyptus. *Eucalyptus gunnii*

Comments: Chop and soak leaves overnight before using. The colours achieved are likely to vary considerably according to the age of the tree, the amount of recent rainfall and the season. Leaves picked in autumn will give olive, gold and brown shades. Those harvested earlier produce more coppery colours.
Photo – Steve Walton.

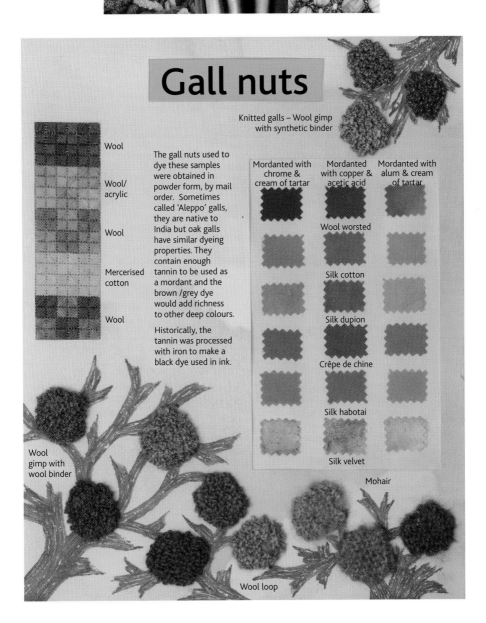

Gall nuts

Knitted galls – Wool gimp with synthetic binder

Wool

Wool/acrylic

Wool

Mercerised cotton

Wool

The gall nuts used to dye these samples were obtained in powder form, by mail order. Sometimes called 'Aleppo' galls, they are native to India but oak galls have similar dyeing properties. They contain enough tannin to be used as a mordant and the brown /grey dye would add richness to other deep colours.

Historically, the tannin was processed with iron to make a black dye used in ink.

Mordanted with chrome & cream of tartar	Mordanted with copper & acetic acid	Mordanted with alum & cream of tartar
	Wool worsted	
	Silk cotton	
	Silk dupion	
	Crêpe de chine	
	Silk habotai	
	Silk velvet	
	Mohair	

Wool gimp with wool binder

Wool loop

Gall nuts. *Cynips*

Comments: These are the nut-like growths that form around gall wasp eggs laid in tree bark. Gall nuts are rich in tannin and therefore effective as a dye on all types of fibres, including cotton. Using copper as a mordant produces interesting, deep green shades. *Photo – Steve Walton*.

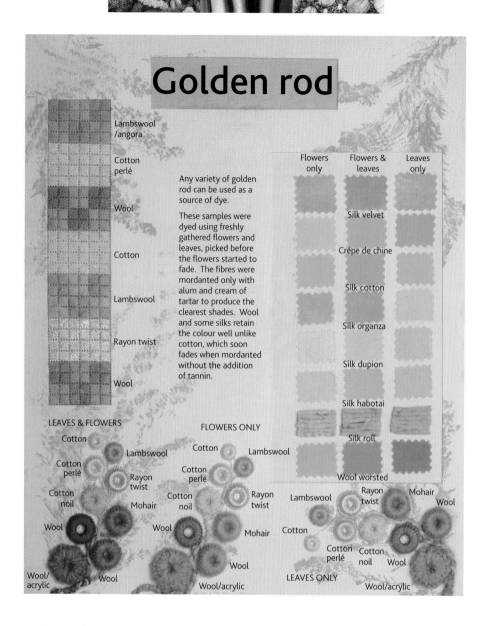

Golden rod

Lambswool /angora

Cotton perlé

Wool

Cotton

Lambswool

Rayon twist

Wool

Any variety of golden rod can be used as a source of dye.

These samples were dyed using freshly gathered flowers and leaves, picked before the flowers started to fade. The fibres were mordanted only with alum and cream of tartar to produce the clearest shades. Wool and some silks retain the colour well unlike cotton, which soon fades when mordanted without the addition of tannin.

	Flowers only	Flowers & leaves	Leaves only
Silk velvet			
Crêpe de chine			
Silk cotton			
Silk organza			
Silk dupion			
Silk habotai			
Silk roll			
Wool worsted			

LEAVES & FLOWERS

Cotton
Lambswool
Cotton perlé
Rayon twist
Cotton noil
Mohair
Wool
Wool
Wool/acrylic

FLOWERS ONLY

Cotton
Lambswool
Cotton perlé
Cotton noil
Rayon twist
Lambswool
Rayon twist
Mohair
Wool
Mohair
Cotton
Wool
Cotton perlé
Cotton noil
Wool
Wool/acrylic

LEAVES ONLY

Wool/acrylic

Golden rod. *Solidago species*

Comments: Fresh flowers give the clearest yellows. Mordant with alum and simmer in the dye for only ten minutes. The addition of leaves moves the shades towards olive/brown. Frozen flowers and leaves work in the same way. Dried material produces darker shades. *Photo – Steve Walton*.

Henna

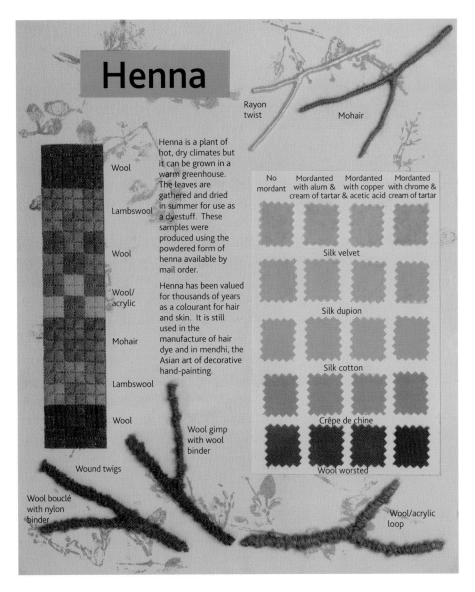

Rayon twist

Mohair

Wool

Lambswool

Wool

Wool/ acrylic

Mohair

Lambswool

Wool

Wound twigs

Wool bouclé with nylon binder

Wool gimp with wool binder

Wool/acrylic loop

Henna is a plant of hot, dry climates but it can be grown in a warm greenhouse. The leaves are gathered and dried in summer for use as a dyestuff. These samples were produced using the powdered form of henna available by mail order.

Henna has been valued for thousands of years as a colourant for hair and skin. It is still used in the manufacture of hair dye and in mendhi, the Asian art of decorative hand-painting.

No mordant	Mordanted with alum & cream of tartar	Mordanted with copper & acetic acid	Mordanted with chrome & cream of tartar

Silk velvet

Silk dupion

Silk cotton

Crêpe de chine

Wool worsted

Henna. *Lawsonia inermus* India

Comments: Henna is a substantive dye but the use of a mordant ensures fastness. It is usually purchased in powder form. Use 50g (2oz) of powder for each 100g (4oz) dry weight of fibre. Strain the dye through a fine mesh sieve to remove as many powder grains as possible before immersing fibres. *Photo – Steve Walton*.

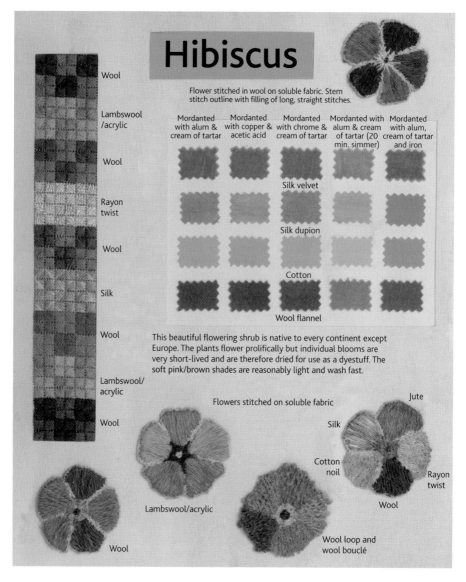

Hibiscus

Flower stitched in wool on soluble fabric. Stem stitch outline with filling of long, straight stitches.

Wool

Lambswool /acrylic

	Mordanted with alum & cream of tartar	Mordanted with copper & acetic acid	Mordanted with chrome & cream of tartar	Mordanted with alum & cream of tartar (20 min. simmer)	Mordanted with alum, cream of tartar and iron

Wool

Silk velvet

Rayon twist

Silk dupion

Wool

Cotton

Silk

Wool flannel

Wool

This beautiful flowering shrub is native to every continent except Europe. The plants flower prolifically but individual blooms are very short-lived and are therefore dried for use as a dyestuff. The soft pink/brown shades are reasonably light and wash fast.

Lambswool/ acrylic

Flowers stitched on soluble fabric

Jute

Wool

Silk

Cotton noil

Rayon twist

Wool

Lambswool/acrylic

Wool

Wool loop and wool bouclé

Wool

Hibiscus. *Hibiscus species* Africa, America, Asia, Australia

Comments: The dried flowers produce a rich, wine-coloured dyebath but this depth of colour is lost at the first rinsing stage. The outcome ranges from dusky pink, through grey to brown. To retain as much of the pink colour as possible, use only warm water for washing and rinsing. *Photo – Steve Walton.*

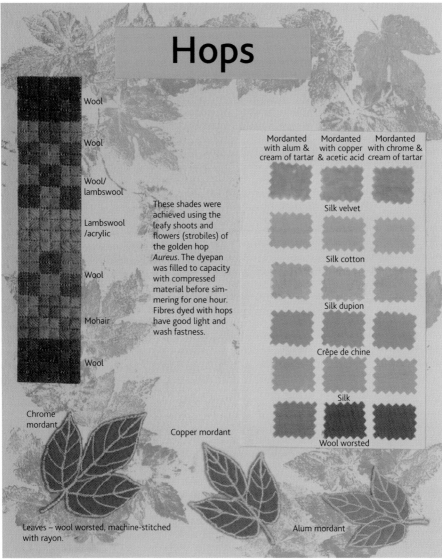

Hops

Wool

Wool

Wool/
lambswool

Lambswool
/acrylic

Wool

Mohair

Wool

Chrome
mordant

Copper mordant

Leaves – wool worsted, machine-stitched
with rayon.

These shades were achieved using the leafy shoots and flowers (strobiles) of the golden hop *Aureus*. The dyepan was filled to capacity with compressed material before simmering for one hour. Fibres dyed with hops have good light and wash fastness.

	Mordanted with alum & cream of tartar	Mordanted with copper & acetic acid	Mordanted with chrome & cream of tartar
Silk velvet			
Silk cotton			
Silk dupion			
Crêpe de chine			
Silk			
Wool worsted			

Alum mordant

Hops. *Humulus lupulus* ('*Aureus*' variety)

Comments: Use the largest quantity of fresh leaves and flowers that can be fitted into the dyepot. Simmer for one hour. Gold/brown shades are produced on wool, soft pink/tan on silk. *Photo – Steve Walton.*

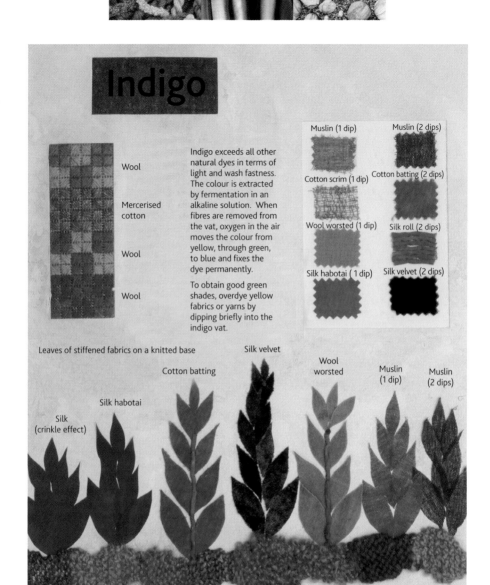

Indigo

Wool

Mercerised cotton

Wool

Wool

Indigo exceeds all other natural dyes in terms of light and wash fastness. The colour is extracted by fermentation in an alkaline solution. When fibres are removed from the vat, oxygen in the air moves the colour from yellow, through green, to blue and fixes the dye permanently.

To obtain good green shades, overdye yellow fabrics or yarns by dipping briefly into the indigo vat.

Muslin (1 dip) Muslin (2 dips)

Cotton scrim (1 dip) Cotton batting (2 dips)

Wool worsted (1 dip) Silk roll (2 dips)

Silk habotai (1 dip) Silk velvet (2 dips)

Leaves of stiffened fabrics on a knitted base Silk velvet

Cotton batting

Silk habotai

Silk (crinkle effect)

Wool worsted Muslin (1 dip) Muslin (2 dips)

Cotton perle Wool gimp Mohair Mercerised cotton Wool loop Wool Wool gimp

Indigo. *Indigofera* species　　　India, N.Africa

Comments: Indigo is a substantive vat dye and needs no mordant. The preparation of the vat needs care but is not difficult (*see Chapter 2*). Once made, the simple process of dipping and airing produces a range of strong, permanent shades of blue. Indigo will dye any natural material without damaging the structure e.g. dried flowers and seedheads. *Photo – Steve Walton*

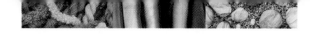

Indigo and Turmeric

Wool

Cotton perlé

These samples illustrate the effect of overdyeing a dark shade with a lighter one: the darker shade (indigo) remains dominant. To have more control over the outcome, the lighter shade should be dyed first.

Wool

Lambswool

If these samples were to be exposed to light for a prolonged period, the dominance of the indigo would increase as the turmeric faded.

Cotton perlé

Mohair

Hand twisted cords on wool flannel

Wool Mohair Wool loop Wool gimp Cotton

	Overdyed once	Overdyed twice
Silk velvet		
Silk dupion		
Silk habotai		
Silk cotton		
Silk carrier rods		
Cotton batting		
Muslin		

Wool on silk habotai

Wool on silk dupion

Leaf designs in back stitch

Indigo and Turmeric.

Comments: The easiest way to produce strong, reliable greens is to overdye predyed yellow fibres with indigo (*see Chapter 2*). Dip the yellow materials briefly into the vat and air. Repeat this process until the right depth of colour is achieved. Reversing this process, i.e. simmering predyed blue fibres in a pan of yellow dye, produces darker, bluer greens. *Photo – Steve Walton*.

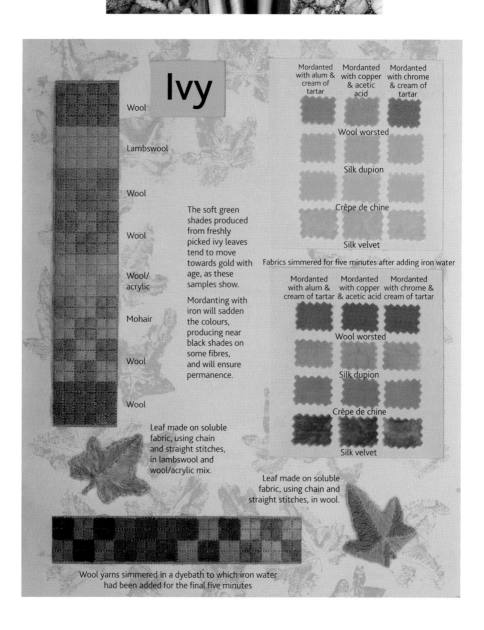

Ivy

	Mordanted with alum & cream of tartar	Mordanted with copper & acetic acid	Mordanted with chrome & cream of tartar
Wool			
Wool worsted			
Lambswool			
Silk dupion			
Wool			
Crêpe de chine			
Wool			
Silk velvet			

The soft green shades produced from freshly picked ivy leaves tend to move towards gold with age, as these samples show.

Mordanting with iron will sadden the colours, producing near black shades on some fibres, and will ensure permanence.

Fabrics simmered for five minutes after adding iron water

	Mordanted with alum & cream of tartar	Mordanted with copper & acetic acid	Mordanted with chrome & cream of tartar
Wool/acrylic			
Wool worsted			
Mohair			
Silk dupion			
Wool			
Crêpe de chine			
Wool			
Silk velvet			

Leaf made on soluble fabric, using chain and straight stitches, in lambswool and wool/acrylic mix.

Leaf made on soluble fabric, using chain and straight stitches, in wool.

Wool yarns simmered in a dyebath to which iron water had been added for the final five minutes

Ivy. *Hedera helix*

Comments: This is one of the few plants to produce green. Chop the leaves and soak overnight before using. The colours tend to fade on silk but are reasonably fast on wool. The addition of iron, as an after-mordant, ensures fastness but moves the colours towards grey/black. *Photo – Steve Walton.*

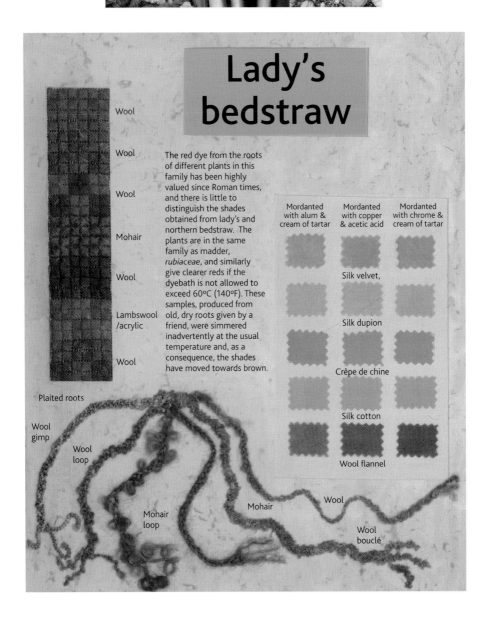

Lady's bedstraw

The red dye from the roots of different plants in this family has been highly valued since Roman times, and there is little to distinguish the shades obtained from lady's and northern bedstraw. The plants are in the same family as madder, *rubiaceae*, and similarly give clearer reds if the dyebath is not allowed to exceed 60°C (140°F). These samples, produced from old, dry roots given by a friend, were simmered inadvertently at the usual temperature and, as a consequence, the shades have moved towards brown.

Wool
Wool
Wool
Mohair
Wool
Lambswool /acrylic
Wool

Plaited roots
Wool gimp
Wool loop
Mohair loop
Mohair
Wool
Wool bouclé

	Mordanted with alum & cream of tartar	Mordanted with copper & acetic acid	Mordanted with chrome & cream of tartar
Silk velvet,			
Silk dupion			
Crêpe de chine			
Silk cotton			
Wool flannel			

Lady's bedstraw. *Galium verum*

Comments: Roots should be at least three years old before they are lifted for use as a dyestuff. It is illegal to dig up roots from the wild, but lady's bedstraw can be grown easily from seed, available from specialist nurseries. Growing the plants in a container prevents spreading and makes it easier to harvest the roots.
Photo – Steve Walton.

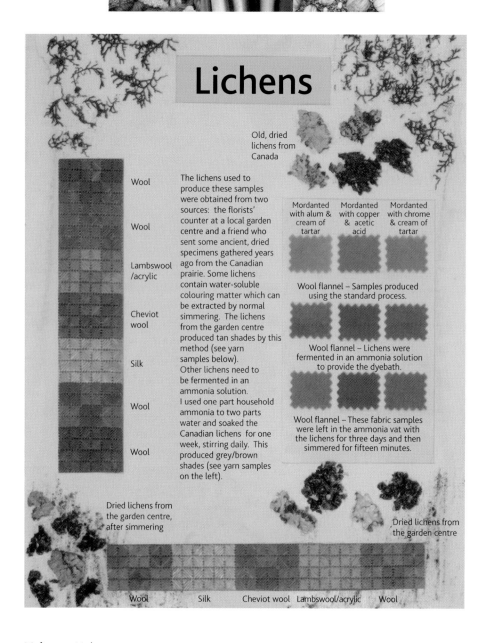

Lichens

Old, dried lichens from Canada

Wool

Wool

Lambswool /acrylic

Cheviot wool

Silk

Wool

Wool

The lichens used to produce these samples were obtained from two sources: the florists' counter at a local garden centre and a friend who sent some ancient, dried specimens gathered years ago from the Canadian prairie. Some lichens contain water-soluble colouring matter which can be extracted by normal simmering. The lichens from the garden centre produced tan shades by this method (see yarn samples below). Other lichens need to be fermented in an ammonia solution. I used one part household ammonia to two parts water and soaked the Canadian lichens for one week, stirring daily. This produced grey/brown shades (see yarn samples on the left).

| Mordanted with alum & cream of tartar | Mordanted with copper & acetic acid | Mordanted with chrome & cream of tartar |

Wool flannel – Samples produced using the standard process.

Wool flannel – Lichens were fermented in an ammonia solution to provide the dyebath.

Wool flannel – These fabric samples were left in the ammonia vat with the lichens for three days and then simmered for fifteen minutes.

Dried lichens from the garden centre, after simmering

Dried lichens from the garden centre

Wool Silk Cheviot wool Lambswool/acrylic Wool

Lichens. *Lichenes*

Comments: Lichens thrive only where there is no air pollution and, as a consequence, are becoming increasingly rare. Regeneration takes many years and so gathering from the wild can no longer be justified. Some will produce dye using the standard process (simmering); others need to be soaked for several weeks in a solution of one part ammonia to two parts water in a screw-top jar and stirred daily. The colours are entirely fast. *Photo – Steve Walton.*

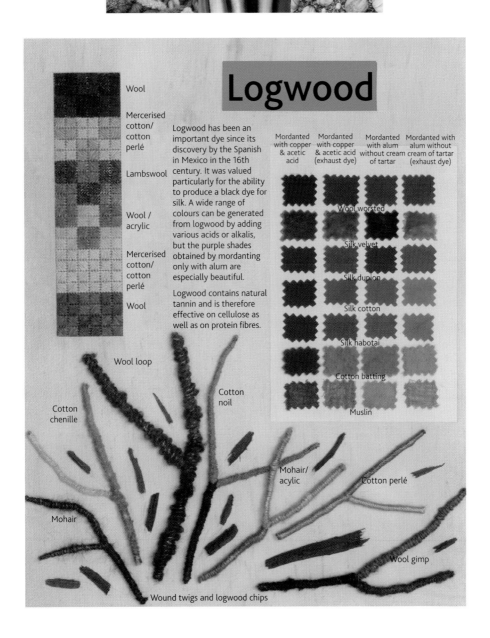

Logwood. *Haematoxylon campecianum* Central and S.America

Comments: Logwood is usually purchased as heartwood chips. It is a reliable and inexpensive dye and offers the easiest way to obtain purple. Mordanted with copper and/or overdyed with indigo, it will produce near black shades. Use only 30g (1oz) per 100g (4oz) dry weight of fibres. Cream of tartar should not be used in the mordanting process because it will turn the lovely purple shades to brown. The dyebath and the logwood chips can be reused many times. *Photo – Steve Walton.*

73

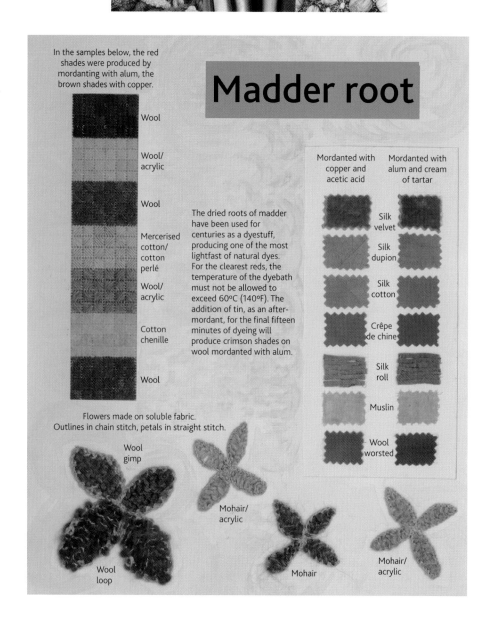

In the samples below, the red shades were produced by mordanting with alum, the brown shades with copper.

Madder root

Wool

Wool/ acrylic

Wool

Mercerised cotton/ cotton perlé

Wool/ acrylic

Cotton chenille

Wool

The dried roots of madder have been used for centuries as a dyestuff, producing one of the most lightfast of natural dyes. For the clearest reds, the temperature of the dyebath must not be allowed to exceed 60°C (140°F). The addition of tin, as an after-mordant, for the final fifteen minutes of dyeing will produce crimson shades on wool mordanted with alum.

Mordanted with copper and acetic acid		Mordanted with alum and cream of tartar
	Silk velvet	
	Silk dupion	
	Silk cotton	
	Crêpe de chine	
	Silk roll	
	Muslin	
	Wool worsted	

Flowers made on soluble fabric.
Outlines in chain stitch, petals in straight stitch.

Wool gimp

Mohair/ acrylic

Wool loop

Mohair

Mohair/ acrylic

Madder root (1) *Rubia tinctoria*

Comments: Soak the chopped roots overnight before use. Obtaining good reds from madder root needs careful control. Use a thermometer to check the dyebath as the temperature is raised slowly to 60°C and maintained at that level for one hour. If the temperature is allowed to exceed this, the colours will move towards orange. *Photo – Steve Walton.*

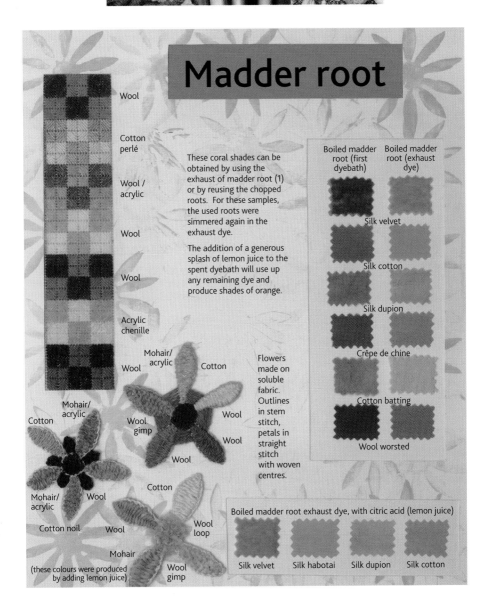

Madder root

Wool

Cotton perlé

Wool / acrylic

Wool

Wool

Acrylic chenille

Mohair/ acrylic

Wool

Cotton

Mohair/ acrylic

Cotton

Wool gimp

Wool

Mohair/ acrylic

Wool

Cotton noil

Wool

Mohair

(these colours were produced by adding lemon juice)

Cotton

Wool

Wool

Wool loop

Wool gimp

These coral shades can be obtained by using the exhaust of madder root (1) or by reusing the chopped roots. For these samples, the used roots were simmered again in the exhaust dye.

The addition of a generous splash of lemon juice to the spent dyebath will use up any remaining dye and produce shades of orange.

Flowers made on soluble fabric. Outlines in stem stitch, petals in straight stitch with woven centres.

Boiled madder root (first dyebath) | Boiled madder root (exhaust dye)

Silk velvet

Silk cotton

Silk dupion

Crêpe de chine

Cotton batting

Wool worsted

Boiled madder root exhaust dye, with citric acid (lemon juice)

Silk velvet | Silk habotai | Silk dupion | Silk cotton

Madder root (2) *Rubia tinctoria*

Comments: If madder root dye is allowed to boil, the colours move towards coral/orange/brown. To obtain a wider range of colours from the same roots, produce reds by keeping the dyebath below simmering point (see opposite). After removing these fibres, return the strained roots to the same dyebath and bring up to the boil. Simmer for 45 minutes, strain and proceed to dye as usual to obtain coral shades.
Photo – Steve Walton.

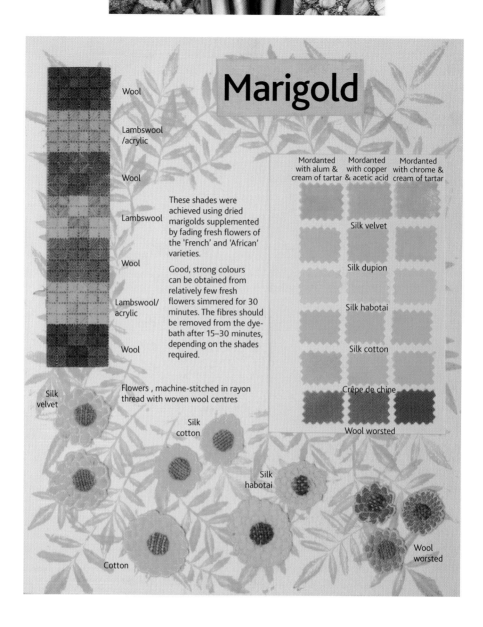

Wool

Lambswool /acrylic

Wool

Marigold

	Mordanted with alum & cream of tartar	Mordanted with copper & acetic acid	Mordanted with chrome & cream of tartar

Lambswool

These shades were achieved using dried marigolds supplemented by fading fresh flowers of the 'French' and 'African' varieties.

Wool

Lambswool/ acrylic

Good, strong colours can be obtained from relatively few fresh flowers simmered for 30 minutes. The fibres should be removed from the dye-bath after 15–30 minutes, depending on the shades required.

Silk velvet

Silk dupion

Silk habotai

Wool

Silk cotton

Silk velvet

Flowers, machine-stitched in rayon thread with woven wool centres

Crêpe de chine

Silk cotton

Wool worsted

Silk habotai

Cotton

Wool worsted

Marigolds. *Tagetes species*

Comments: Any species of marigold will produce good colour. The shades will be deeper if the darker flowers of African marigolds are included. Regularly removing the fading blooms extends the flowering period and, if these are frozen or dried, it is possible to collect enough for a dyebath from only one plant. When dyeing with marigolds, work with good ventilation or outside because of the pungent smell. *Photo – Steve Walton.*

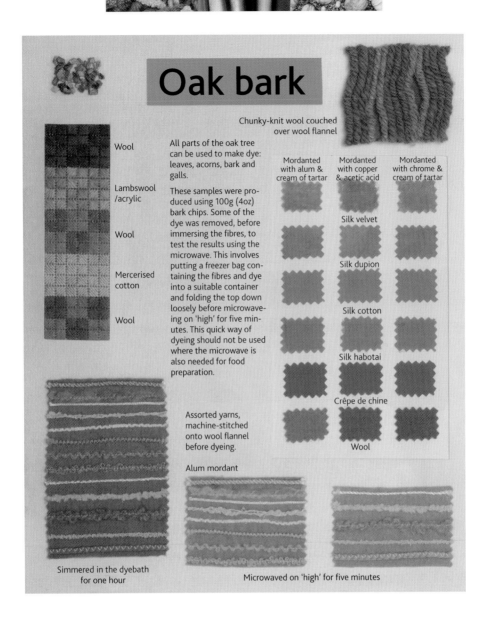

Oak bark

Chunky-knit wool couched over wool flannel

All parts of the oak tree can be used to make dye: leaves, acorns, bark and galls.

These samples were produced using 100g (4oz) bark chips. Some of the dye was removed, before immersing the fibres, to test the results using the microwave. This involves putting a freezer bag containing the fibres and dye into a suitable container and folding the top down loosely before microwaveing on 'high' for five minutes. This quick way of dyeing should not be used where the microwave is also needed for food preparation.

Wool

Lambswool /acrylic

Wool

Mercerised cotton

Wool

	Mordanted with alum & cream of tartar	Mordanted with copper & acetic acid	Mordanted with chrome & cream of tartar
Silk velvet			
Silk dupion			
Silk cotton			
Silk habotai			
Crêpe de chine			
Wool			

Assorted yarns, machine-stitched onto wool flannel before dyeing.

Alum mordant

Simmered in the dyebath for one hour

Microwaved on 'high' for five minutes

Oak bark. *Quercus robur*

Comments: Soak the chips of bark for at least 24 hours before using. The take-up of colour is good on wool and silk but, using the standard process, the dye has very little effect on cotton or rayon. For worthwhile results, cellulose fibres need to be mordanted differently (*see Chapter 2*). The bark chips can be dried and stored for reuse. *Photo – Steve Walton.*

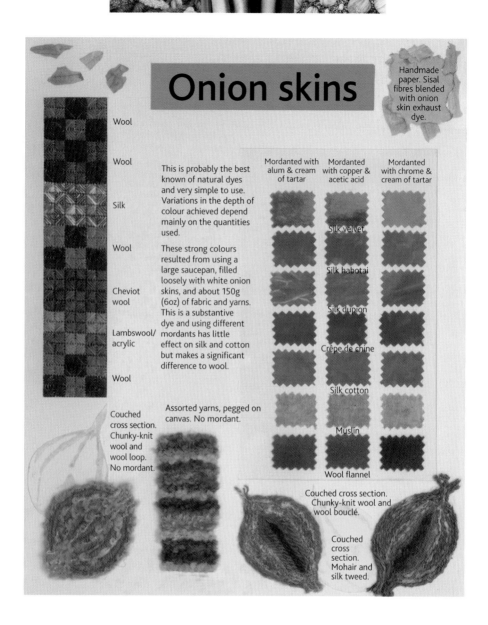

Handmade paper. Sisal fibres blended with onion skin exhaust dye.

Onion skins

Wool

Wool

Silk

This is probably the best known of natural dyes and very simple to use. Variations in the depth of colour achieved depend mainly on the quantities used.

Wool

Cheviot wool

Lambswool/ acrylic

These strong colours resulted from using a large saucepan, filled loosely with white onion skins, and about 150g (6oz) of fabric and yarns. This is a substantive dye and using different mordants has little effect on silk and cotton but makes a significant difference to wool.

Wool

	Mordanted with alum & cream of tartar	Mordanted with copper & acetic acid	Mordanted with chrome & cream of tartar
		Silk velvet	
		Silk habotai	
		Silk dupion	
		Crêpe de chine	
		Silk cotton	
		Muslin	
		Wool flannel	

Couched cross section. Chunky-knit wool and wool loop. No mordant.

Assorted yarns, pegged on canvas. No mordant.

Couched cross section. Chunky-knit wool and wool bouclé.

Couched cross section. Mohair and silk tweed.

Onion skins. *Allium cepa*

Comments: Only the papery, outer skins are used. They can be stored in a dry, dark place for a very long time and remain viable as a source of dye. To obtain the strongest colours, use onion skins generously. The colour is released after only a short simmer. This is one of the easiest, simplest dyes to use. *Photo – Steve Walton.*

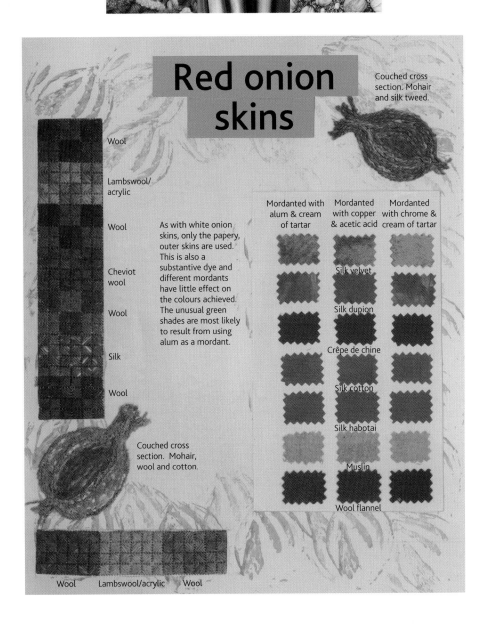

Red onion skins

Couched cross section. Mohair and silk tweed.

Wool

Lambswool/ acrylic

Wool

As with white onion skins, only the papery, outer skins are used. This is also a substantive dye and different mordants have little effect on the colours achieved. The unusual green shades are most likely to result from using alum as a mordant.

Cheviot wool

Wool

Silk

Wool

Couched cross section. Mohair, wool and cotton.

Mordanted with alum & cream of tartar	Mordanted with copper & acetic acid	Mordanted with chrome & cream of tartar
	Silk velvet	
	Silk dupion	
	Crêpe de chine	
	Silk cotton	
	Silk habotai	
	Muslin	
	Wool flannel	

Wool Lambswool/acrylic Wool

Red onion skins.

Comments: Red and white onion skins are usually available on request from greengrocers or supermarkets. When red onion skins are added to white it results in deeper, redder shades. When used on their own, they produce a range of colours from greens to rich browns. *Photo – Steve Walton.*

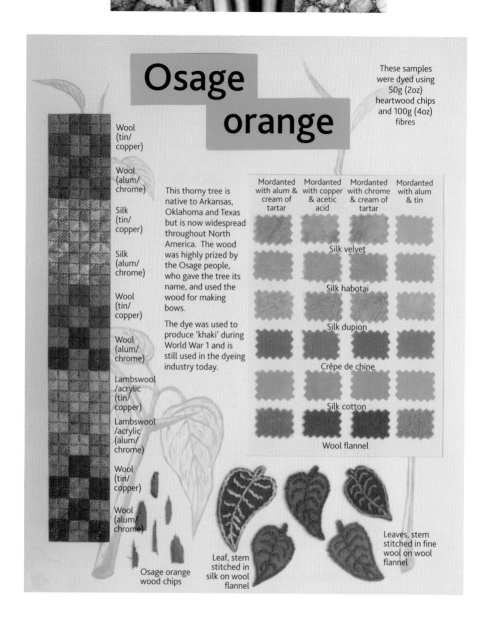

Osage orange

These samples were dyed using 50g (2oz) heartwood chips and 100g (4oz) fibres

Wool (tin/copper)

Wool (alum/chrome)

Silk (tin/copper)

Silk (alum/chrome)

Wool (tin/copper)

Wool (alum/chrome)

Lambswool /acrylic (tin/copper)

Lambswool /acrylic (alum/chrome)

Wool (tin/copper)

Wool (alum/chrome)

This thorny tree is native to Arkansas, Oklahoma and Texas but is now widespread throughout North America. The wood was highly prized by the Osage people, who gave the tree its name, and used the wood for making bows.

The dye was used to produce 'khaki' during World War 1 and is still used in the dyeing industry today.

Mordanted with alum & cream of tartar	Mordanted with copper & acetic acid	Mordanted with chrome & cream of tartar	Mordanted with alum & tin

Silk velvet

Silk habotai

Silk dupion

Crêpe de chine

Silk cotton

Wool flannel

Osage orange wood chips

Leaf, stem stitched in silk on wool flannel

Leaves, stem stitched in fine wool on wool flannel

Osage orange. *Maclura pomifera* Central America

Comments: Soak these heartwood chips for a few days before use. This is a substantive dye, rich in natural tannins, and it will colour both protein and cellulose fibres effectively. Using a range of mordants makes little difference to the strong, bright colours that are consistently achieved. *Photo – Steve Walton*.

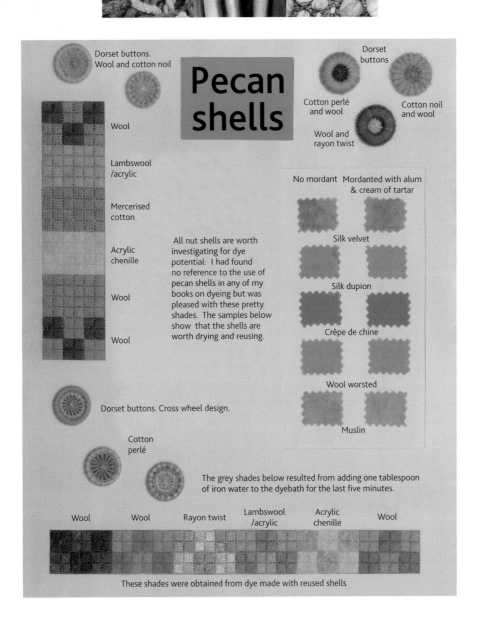

**Pecan
shells**

Dorset buttons.
Wool and cotton noil

Wool

Lambswool
/acrylic

Mercerised
cotton

Acrylic
chenille

Wool

Wool

Dorset buttons

Cotton perlé
and wool

Cotton noil
and wool

Wool and
rayon twist

All nut shells are worth
investigating for dye
potential: I had found
no reference to the use of
pecan shells in any of my
books on dyeing but was
pleased with these pretty
shades. The samples below
show that the shells are
worth drying and reusing.

No mordant Mordanted with alum
& cream of tartar

Silk velvet

Silk dupion

Crêpe de chine

Wool worsted

Muslin

Dorset buttons. Cross wheel design.

Cotton
perlé

The grey shades below resulted from adding one tablespoon
of iron water to the dyebath for the last five minutes.

| Wool | Wool | Rayon twist | Lambswool /acrylic | Acrylic chenille | Wool |

These shades were obtained from dye made with reused shells

Pecan shells. *Carya pecan* Central America

Comments: The shells from about 200g (8oz) pecan nuts will produce good
colour on 100g (4oz) fibres. This dye works well on all natural fibres including
cotton that has been mordanted alongside wool and silk. Crush and soak the
shells overnight before proceeding: they can be dried out and stored for reuse.
Photo – Steve Walton.

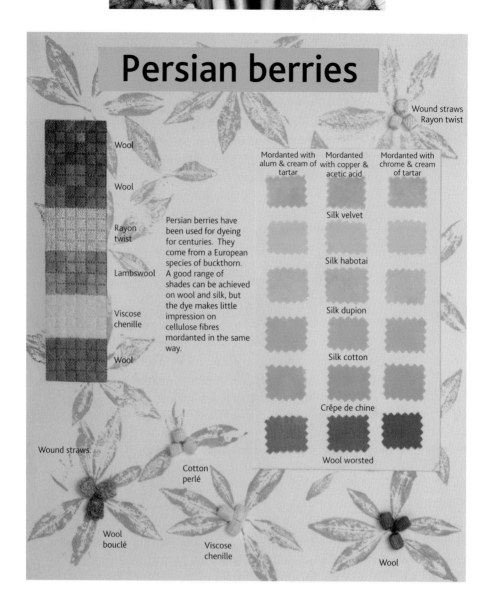

Persian berries

Wound straws
Rayon twist

Wool

Wool

Rayon twist

Lambswool

Viscose chenille

Wool

Persian berries have been used for dyeing for centuries. They come from a European species of buckthorn. A good range of shades can be achieved on wool and silk, but the dye makes little impression on cellulose fibres mordanted in the same way.

Mordanted with alum & cream of tartar	Mordanted with copper & acetic acid	Mordanted with chrome & cream of tartar
	Silk velvet	
	Silk habotai	
	Silk dupion	
	Silk cotton	
	Crêpe de chine	
	Wool worsted	

Wound straws.

Cotton perlé

Wool bouclé

Viscose chenille

Wool

Persian berries. *(Buckthorn) Rhamnus species* S.Europe

Comments: Use only 30g (1oz) dried berries to each 100g (4oz) dry weight of fibres. To extract the maximum amount of colour, grind the dried berries before soaking overnight. Using copper as a mordant will search out whatever green colouring is present. *Photo – Steve Walton*.

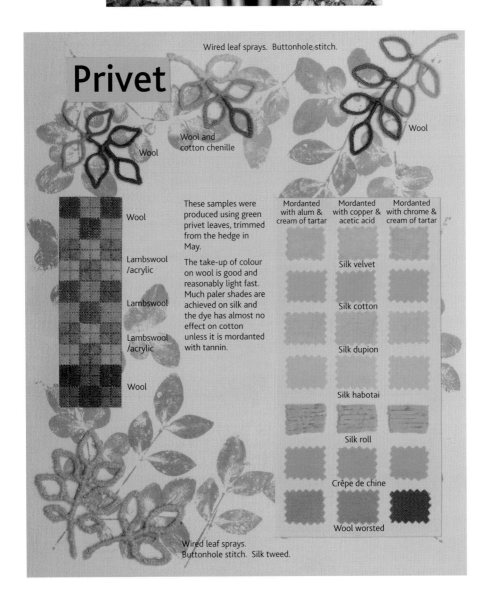

Privet

Wired leaf sprays. Buttonhole stitch.

Wool

Wool and cotton chenille

Wool

Wool

Lambswool /acrylic

Lambswool

Lambswool /acrylic

Wool

These samples were produced using green privet leaves, trimmed from the hedge in May.

The take-up of colour on wool is good and reasonably light fast. Much paler shades are achieved on silk and the dye has almost no effect on cotton unless it is mordanted with tannin.

	Mordanted with alum & cream of tartar	Mordanted with copper & acetic acid	Mordanted with chrome & cream of tartar
Silk velvet			
Silk cotton			
Silk dupion			
Silk habotai			
Silk roll			
Crêpe de chine			
Wool worsted			

Wired leaf sprays.
Buttonhole stitch. Silk tweed.

Privet. *Ligustrum vulgare*

Comments: Use a generous quantity of fresh hedge trimmings. Chop roughly and soak overnight before using. 200g (8oz) for each 100g (4oz) dry weight of fibres will produce a reasonable depth of colour on wool, but, for the strongest shades, use as many leaves as the dyepan will hold. *Photo – Steve Walton*.

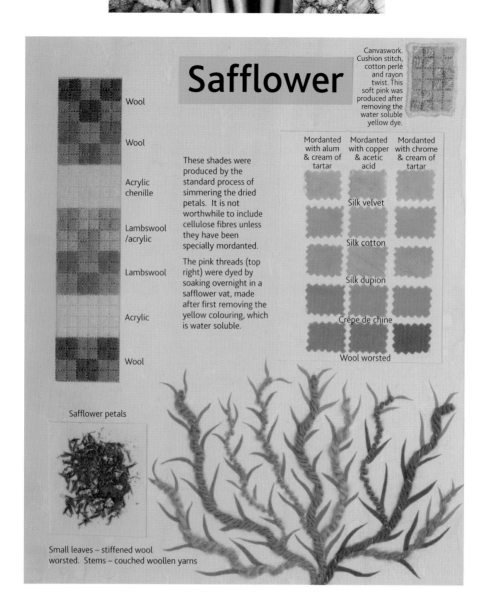

Safflower

Canvaswork. Cushion stitch, cotton perlé and rayon twist. This soft pink was produced after removing the water soluble yellow dye.

Wool

Wool

Acrylic chenille

Lambswool /acrylic

Lambswool

Acrylic

Wool

These shades were produced by the standard process of simmering the dried petals. It is not worthwhile to include cellulose fibres unless they have been specially mordanted.

The pink threads (top right) were dyed by soaking overnight in a safflower vat, made after first removing the yellow colouring, which is water soluble.

Mordanted with alum & cream of tartar	Mordanted with copper & acetic acid	Mordanted with chrome & cream of tartar
	Silk velvet	
	Silk cotton	
	Silk dupion	
	Crêpe de chine	
	Wool worsted	

Safflower petals

Small leaves – stiffened wool worsted. Stems – couched woollen yarns

Safflower. *Carthamus tinctorius* S.Europe, N.Africa, Asia

Comments: Using the standard process, the dried petals produce a limited range of gold/brown shades on wool and silk. However, safflower contains both yellow and red dyes which can be separated. The soluble yellow dye can be extracted by rinsing the florets under running water until it runs clear. This dye can be collected to produce pale lemon colours by the standard process. To obtain the pink/red shades, place the rinsed petals into cold, soft water and add enough washing soda to turn the dyebath red. Strain out the petals and add two teaspoons of white vinegar to the dyebath. Immerse the fibres and soak overnight before rinsing and washing as usual. This gives good results on all fibres, including cotton. *Photo – Steve Walton.*

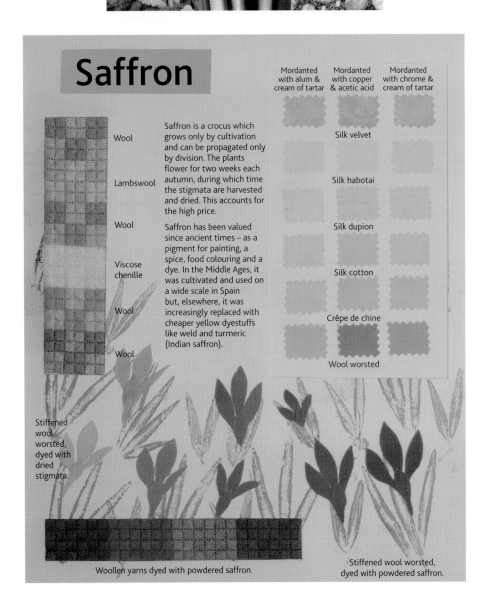

Saffron

	Mordanted with alum & cream of tartar	Mordanted with copper & acetic acid	Mordanted with chrome & cream of tartar

Wool

Lambswool

Wool

Viscose chenille

Wool

Wool

Saffron is a crocus which grows only by cultivation and can be propagated only by division. The plants flower for two weeks each autumn, during which time the stigmata are harvested and dried. This accounts for the high price.

Saffron has been valued since ancient times – as a pigment for painting, a spice, food colouring and a dye. In the Middle Ages, it was cultivated and used on a wide scale in Spain but, elsewhere, it was increasingly replaced with cheaper yellow dyestuffs like weld and turmeric (Indian saffron).

Silk velvet

Silk habotai

Silk dupion

Silk cotton

Crêpe de chine

Wool worsted

Stiffened wool worsted, dyed with dried stigmata.

Woollen yarns dyed with powdered saffron.

Stiffened wool worsted, dyed with powdered saffron.

Saffron. *Crocus sativus* Middle East

Comments: A costly spice, saffron is not a practical option for dyeing more than a handful of threads. However, one pack of saffron from the supermarket (0.5g) will dye 50g (2oz) of fibres to shades of soft yellow and green. Powdered saffron may be available; this is much cheaper and produces shades of coral and soft brown. *Photo – Steve Walton.*

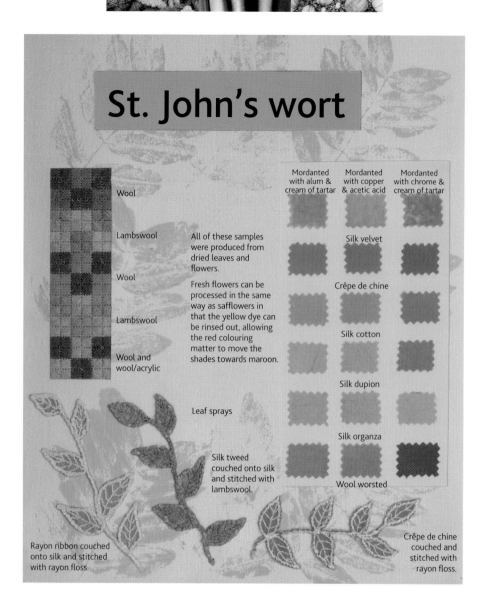

St. John's wort

	Mordanted with alum & cream of tartar	Mordanted with copper & acetic acid	Mordanted with chrome & cream of tartar

Wool

Lambswool

All of these samples were produced from dried leaves and flowers.

Silk velvet

Wool

Fresh flowers can be processed in the same way as safflowers in that the yellow dye can be rinsed out, allowing the red colouring matter to move the shades towards maroon.

Crêpe de chine

Lambswool

Silk cotton

Wool and wool/acrylic

Silk dupion

Leaf sprays

Silk organza

Silk tweed couched onto silk and stitched with lambswool.

Wool worsted

Rayon ribbon couched onto silk and stitched with rayon floss.

Crêpe de chine couched and stitched with rayon floss.

St. John's wort. *Hypericum species*

Comments: The easiest way to obtain the flowering tops is in dried form by mail order. The plant is easy to grow from seed but it can be invasive, as well as noxious to livestock, and it is best controlled by growing in a container. Using the standard process, both fresh and dried material produces shades of gold/green on wool, gold/brown on silk. *Photo – Steve Walton*.

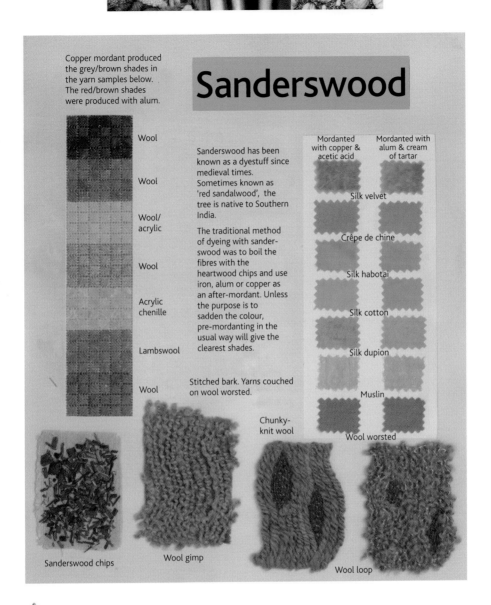

Copper mordant produced the grey/brown shades in the yarn samples below. The red/brown shades were produced with alum.

Sanderswood

Wool

Wool

Wool/acrylic

Wool

Acrylic chenille

Lambswool

Wool

Sanderswood has been known as a dyestuff since medieval times. Sometimes known as 'red sandalwood', the tree is native to Southern India.

The traditional method of dyeing with sanderswood was to boil the fibres with the heartwood chips and use iron, alum or copper as an after-mordant. Unless the purpose is to sadden the colour, pre-mordanting in the usual way will give the clearest shades.

Stitched bark. Yarns couched on wool worsted.

Mordanted with copper & acetic acid	Mordanted with alum & cream of tartar
Silk velvet	
Crêpe de chine	
Silk habotai	
Silk cotton	
Silk dupion	
Muslin	
Wool worsted	

Chunky-knit wool

Sanderswood chips

Wool gimp

Wool loop

Sanderswood. (Red sandalwood) *Pterocarpus santalinus* S.India

Comments: These heartwood chips should be soaked overnight before use. The colours obtained from different consignments can vary from soft pink/brown to orange/rust. The addition of a little washing soda to the dyebath moves the colour towards red. *Photo – Steve Walton*.

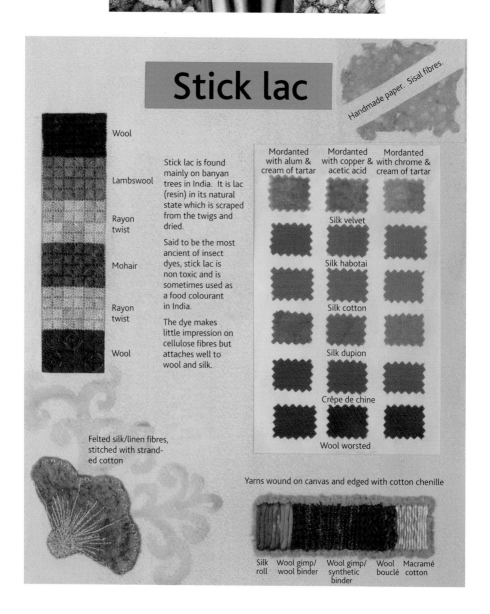

Stick lac

Handmade paper. Sisal fibres.

Wool

Lambswool

Rayon twist

Mohair

Rayon twist

Wool

Stick lac is found mainly on banyan trees in India. It is lac (resin) in its natural state which is scraped from the twigs and dried.

Said to be the most ancient of insect dyes, stick lac is non toxic and is sometimes used as a food colourant in India.

The dye makes little impression on cellulose fibres but attaches well to wool and silk.

Mordanted with alum & cream of tartar	Mordanted with copper & acetic acid	Mordanted with chrome & cream of tartar

Silk velvet

Silk habotai

Silk cotton

Silk dupion

Crêpe de chine

Wool worsted

Felted silk/linen fibres, stitched with stranded cotton

Yarns wound on canvas and edged with cotton chenille

Silk roll	Wool gimp/ wool binder	Wool gimp/ synthetic binder	Wool bouclé	Macramé cotton

Stick lac. *Laccifer lacco* S.E.Asia

Comments: A resin excreted by insects, stick lac is the source of 'shellac' varnish. The pieces of resin should be pounded before use. Stick lac is an expensive dye but a small quantity will colour a lot of fibres. The shades produced are almost identical to cochineal, which is both cheaper and easier to obtain. *Photo – Steve Walton*.

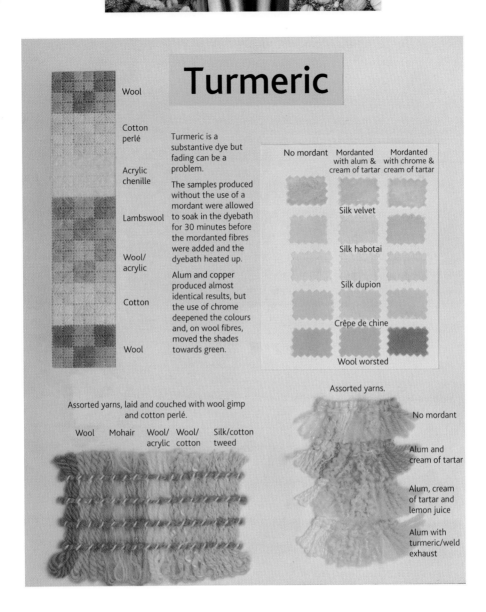

Turmeric

Wool

Cotton perlé

Turmeric is a substantive dye but fading can be a problem.

Acrylic chenille

The samples produced without the use of a mordant were allowed

Lambswool

to soak in the dyebath for 30 minutes before the mordanted fibres were added and the dyebath heated up.

Wool/ acrylic

Cotton

Alum and copper produced almost identical results, but the use of chrome deepened the colours and, on wool fibres, moved the shades towards green.

Wool

No mordant	Mordanted with alum & cream of tartar	Mordanted with chrome & cream of tartar
	Silk velvet	
	Silk habotai	
	Silk dupion	
	Crêpe de chine	
	Wool worsted	

Assorted yarns.

Assorted yarns, laid and couched with wool gimp and cotton perlé.

| Wool | Mohair | Wool/ acrylic | Wool/ cotton | Silk/cotton tweed |

No mordant

Alum and cream of tartar

Alum, cream of tartar and lemon juice

Alum with turmeric/weld exhaust

Turmeric. *Curcuma longa* India, Far East

Comments: Fresh roots are very difficult to find and the easiest way to obtain turmeric is in powdered form from the supermarket. It is a substantive dye but the use of a mordant helps to prevent fading. It takes very little time for turmeric powder to release its colour and it is effective on all natural fibres. The dye should be strained through a fine mesh to remove gritty particles of powder before immersing fibres. *Photo – Steve Walton*.

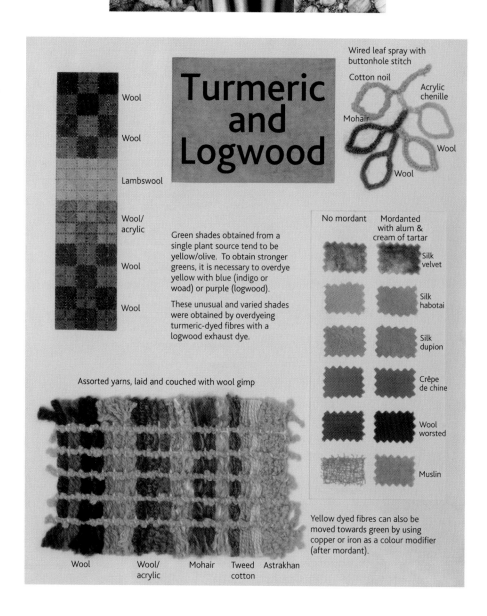

Wired leaf spray with buttonhole stitch

Cotton noil

Acrylic chenille

Mohair

Wool

Wool

Wool

Wool

Wool

Lambswool

Wool/
acrylic

Green shades obtained from a single plant source tend to be yellow/olive. To obtain stronger greens, it is necessary to overdye yellow with blue (indigo or woad) or purple (logwood).

Wool

These unusual and varied shades were obtained by overdyeing turmeric-dyed fibres with a logwood exhaust dye.

Wool

Turmeric and Logwood

No mordant	Mordanted with alum & cream of tartar	
		Silk velvet
		Silk habotai
		Silk dupion
		Crêpe de chine
		Wool worsted
		Muslin

Yellow dyed fibres can also be moved towards green by using copper or iron as a colour modifier (after mordant).

Assorted yarns, laid and couched with wool gimp

Wool · Wool/acrylic · Mohair · Tweed cotton · Astrakhan

Turmeric and Logwood.

Comments: Turmeric is so convenient and easy to use that it is a useful stand-by for producing yellow fibres to be overdyed for greens. Dye the yellow shades first in order to have more control over the outcome. Then simmer the fibres in a weak solution, or the exhaust, of logwood dye to produce soft, grey greens.
Photo – Steve Walton.

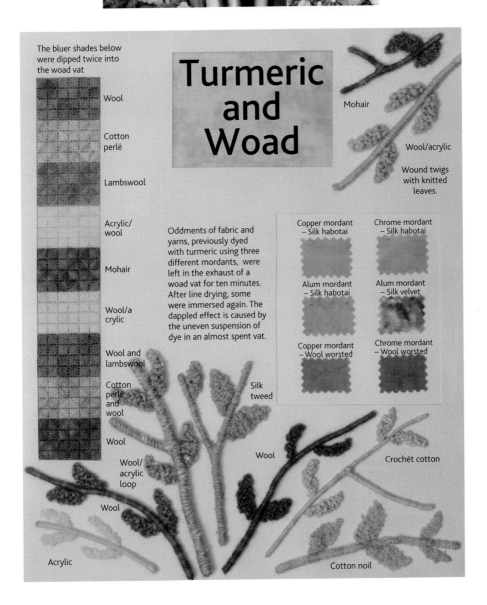

The bluer shades below were dipped twice into the woad vat

Wool

Cotton perlé

Lambswool

Acrylic/wool

Mohair

Wool/acrylic

Wound twigs with knitted leaves.

Turmeric and Woad

Mohair

Wool/a crylic

Wool and lambswool

Cotton perlé and wool

Wool

Wool/acrylic loop

Wool

Acrylic

Oddments of fabric and yarns, previously dyed with turmeric using three different mordants, were left in the exhaust of a woad vat for ten minutes. After line drying, some were immersed again. The dappled effect is caused by the uneven suspension of dye in an almost spent vat.

Copper mordant – Silk habotai

Chrome mordant – Silk habotai

Alum mordant – Silk habotai

Alum mordant – Silk velvet

Copper mordant – Wool worsted

Chrome mordant – Wool worsted

Silk tweed

Wool

Crochét cotton

Cotton noil

Turmeric and Woad

Comments: Immerse the yellow fibres in the woad vat for about five minutes. Remove carefully, trying not to allow drips to fall back into the vat. Air until the greens have fully developed and repeat the dipping and airing process if deeper shades are required. Some interesting, dappled effects can be achieved by using an almost-exhausted woad vat for this process of overdyeing.
Photo – Steve Walton.

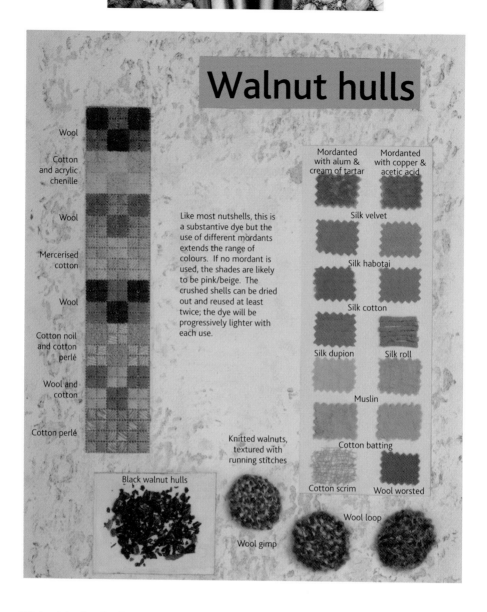

Walnut hulls

Wool

Cotton and acrylic chenille

Wool

Mercerised cotton

Wool

Cotton noil and cotton perlé

Wool and cotton

Cotton perlé

Like most nutshells, this is a substantive dye but the use of different mordants extends the range of colours. If no mordant is used, the shades are likely to be pink/beige. The crushed shells can be dried out and reused at least twice; the dye will be progressively lighter with each use.

Mordanted with alum & cream of tartar

Mordanted with copper & acetic acid

Silk velvet

Silk habotai

Silk cotton

Silk dupion Silk roll

Muslin

Cotton batting

Knitted walnuts, textured with running stitches

Cotton scrim Wool worsted

Wool loop

Black walnut hulls

Wool gimp

Walnut hulls. *Juglans nigra* North America, Europe

Comments: The crushed shells of the American black walnut produce a strong, fast, substantive dye, but pre-mordanting will increase the take-up of colour. Walnut hulls give good results on all natural fibres. The use of iron as an after-mordant produces dark brown/nearly black shades on wool.
Photo – Steve Walton.

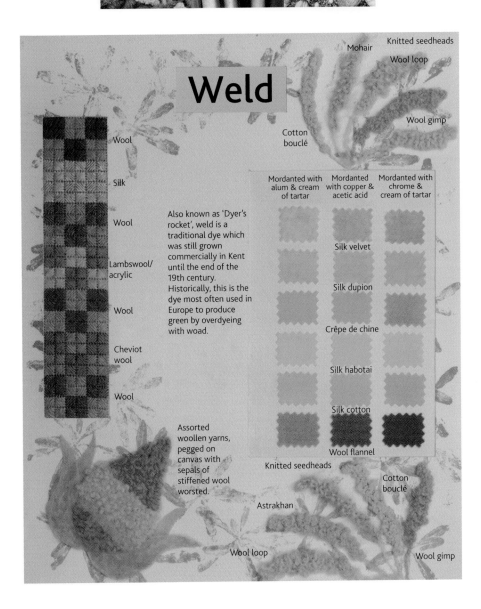

Weld

Mohair
Knitted seedheads
Wool loop
Wool gimp
Cotton bouclé
Wool
Silk
Wool
Lambswool/ acrylic
Wool
Cheviot wool
Wool

Also known as 'Dyer's rocket', weld is a traditional dye which was still grown commercially in Kent until the end of the 19th century. Historically, this is the dye most often used in Europe to produce green by overdyeing with woad.

Assorted woollen yarns, pegged on canvas with sepals of stiffened wool worsted.

Mordanted with alum & cream of tartar	Mordanted with copper & acetic acid	Mordanted with chrome & cream of tartar
	Silk velvet	
	Silk dupion	
	Crêpe de chine	
	Silk habotai	
	Silk cotton	
	Wool flannel	

Knitted seedheads
Cotton bouclé
Astrakhan
Wool loop
Wool gimp

Weld. (Dyer's rocket) *Reseda luteola*

Comments: Weld is the yellow dye of antiquity, known to have been used by the Romans. This biennial plant is sometimes found by the wayside or in neglected areas and it can be grown easily from seed in poor garden soil. The whole plant can be used as a dyestuff but the clearest, brightest yellows are obtained from freshly harvested leaves and flowers, mordanted with alum.
Photo – Steve Walton.

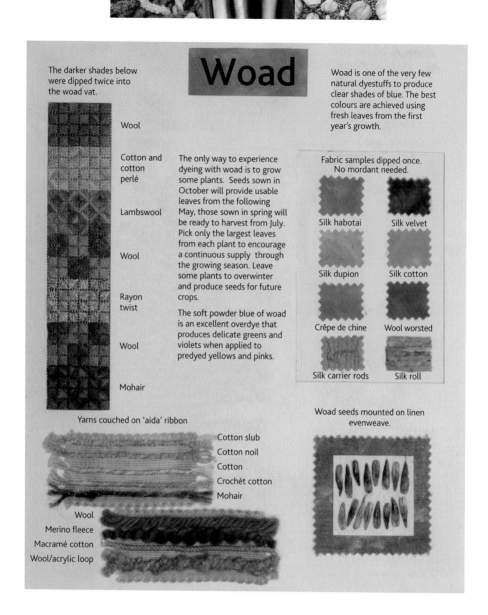

The darker shades below were dipped twice into the woad vat.

Woad

Woad is one of the very few natural dyestuffs to produce clear shades of blue. The best colours are achieved using fresh leaves from the first year's growth.

Wool

Cotton and cotton perlé

Lambswool

Wool

Rayon twist

Wool

Mohair

The only way to experience dyeing with woad is to grow some plants. Seeds sown in October will provide usable leaves from the following May, those sown in spring will be ready to harvest from July. Pick only the largest leaves from each plant to encourage a continuous supply through the growing season. Leave some plants to overwinter and produce seeds for future crops.

The soft powder blue of woad is an excellent overdye that produces delicate greens and violets when applied to predyed yellows and pinks.

Fabric samples dipped once. No mordant needed.

Silk habotai Silk velvet

Silk dupion Silk cotton

Crêpe de chine Wool worsted

Silk carrier rods Silk roll

Yarns couched on 'aida' ribbon

Cotton slub
Cotton noil
Cotton
Crochét cotton
Mohair

Wool
Merino fleece
Macramé cotton
Wool/acrylic loop

Woad seeds mounted on linen evenweave.

Woad. *Isatis tinctoria*

Comments: Woad is a native biennial that is easy to grow from seed in the garden: it thrives in rich, moist soil. It provided the blue in European dyeing for hundreds of years before the arrival of indigo. The clearest blues are obtained from fresh leaves harvested in the first year of growth. It is a vat dye and therefore requires no mordant (*see Chapter 2*). Woad blue is completely light and wash fast. *Photo – Steve Walton*.

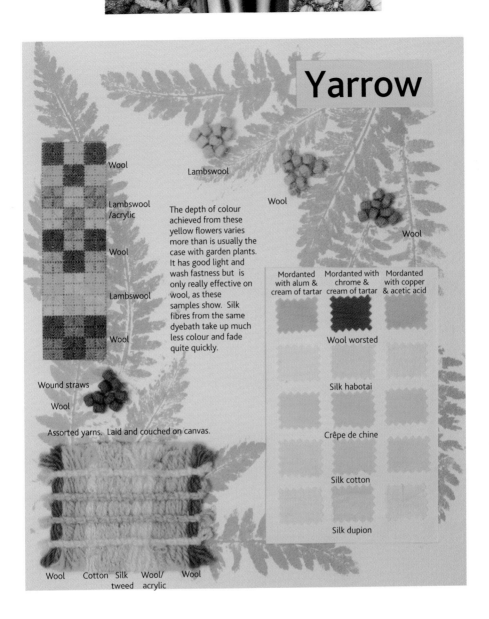

Yarrow

Wool

Lambswool

Lambswool
/acrylic

Wool

Lambswool

Wool

Wool

Wool

Wool

The depth of colour achieved from these yellow flowers varies more than is usually the case with garden plants. It has good light and wash fastness but is only really effective on wool, as these samples show. Silk fibres from the same dyebath take up much less colour and fade quite quickly.

Wound straws

Wool

Assorted yarns. Laid and couched on canvas.

Wool Cotton Silk Wool/ Wool
 tweed acrylic

Mordanted with alum & cream of tartar	Mordanted with chrome & cream of tartar	Mordanted with copper & acetic acid
Wool worsted		
Silk habotai		
Crêpe de chine		
Silk cotton		
Silk dupion		

Yarrow. *Achillea filipendulina* ('Gold plate' variety)

Comments: Yarrow is a tall, native perennial that will grow happily at the back of a flower border. It produces strong colours on wool fibres but has much less impact on silk. Using the leaves without the flowers, with copper as a mordant, gives a strong green on wool. *Photo – Steve Walton.*

Gallery

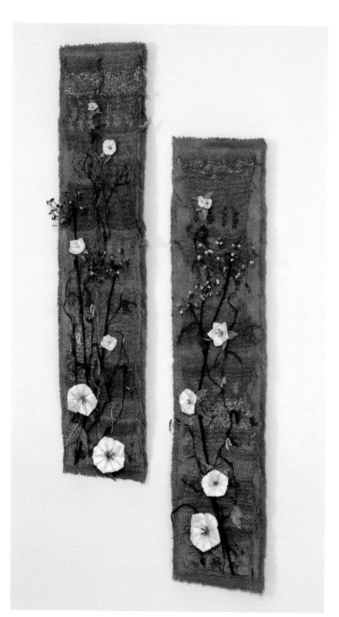

Indigo wall hangings.
*108 x 24cm
(42.5 x 9.5 in.).*

This pair of long, narrow hangings was inspired by the sleeve bands of Chinese embroidery. Adding a contrast of white flowers to a highly textured, dark background was suggested by convolvulus flowers (bindweed) in a hedgerow. I decided to use indigo because the blue and white scheme would be complemented by the plates on display in the dining room, and also because using a vat dye would incur no risk of felting the knitted hedge.

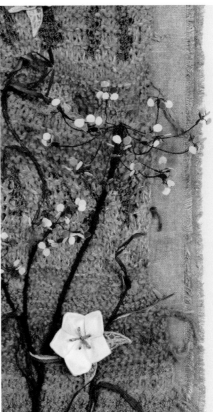

The hedge background is made up of knitted strips of assorted yarns, including some synthetic. Casting stitches on and off as the strips grew produced a more organic edge. When they came out of the indigo vat, the yarns had taken up the dye differently to create a background of varied tones and textures.

The white flowers are made from wired silk satin, with hand-stitching and cotton noil stamens in the centres. The long cow parsley stems are constructed from lengths of copper wire twisted together for thickness and strength, and then wound with thin strips of muslin. The seeds are tiny circles of stiffened silk in several shades of blue, including an almost white piece that was dipped only briefly into the indigo.

Lengths of raffia absorbed the dye really well and these dark blue blades of 'grass' were perfect for weaving into the wild hedge.

The finished pieces were stitched onto a backing of two lengths of frayed silk noil fabric interlined with craft Vilene to strengthen and support the shape.

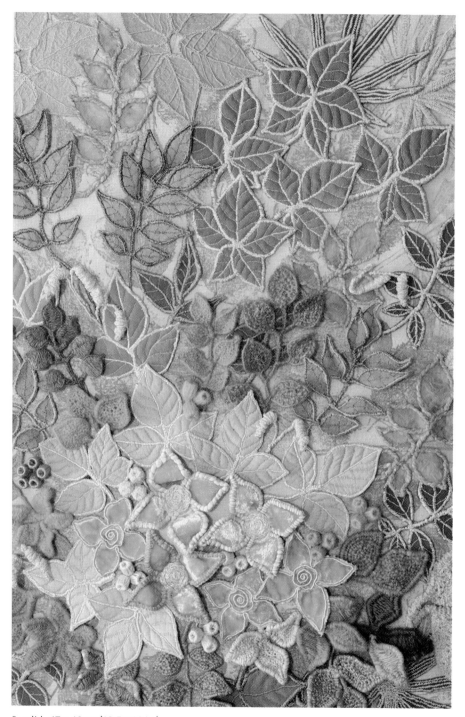

Box lid. *47 x 40cm (18.5 x 16 in.)*.

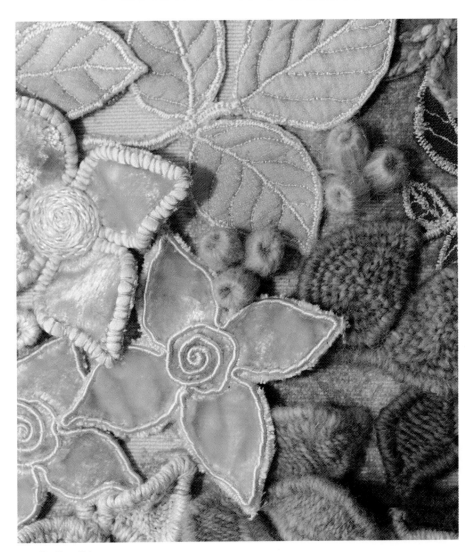

Detail of box lid.

This piece was originally planned as a cover for a handmade book about natural dyes. Each page was to be a sample board featuring a different source of dye. Chapter 4 shows how this project took on a life of its own, well beyond the confines of a book! The 'book cover' became the lid of a box in which the boards would be stored.

The idea for the design came from the varied forms and structures of leaves in the garden in January. This, coupled with an interest in the techniques of stumpwork, led to a three-dimensional design brief.

I dyed a wide range of fabrics and threads with the dried flowers and leaves of golden rod, using alum, copper and chrome mordants. Some of the leaves are worked in needlelace, stitched over a fine wire frame; others are machine-quilted. The larger, central flowers are made of silk velvet edged with wired silk roll. I used short sections of plastic straws, wound with wool or cotton, to make the berries and gathered tubular ribbon onto wire for catkins.

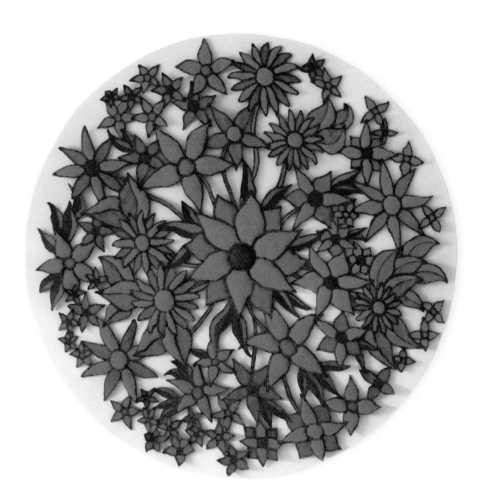

Circular panel. *63 cm (25 in.) diameter.*

The design for this piece was drawn free-hand, using the type of simplified flower and leaf shapes that are found in lace patterns. I wanted a bold, red panel to put on the empty white wall in the hallway, which has a wine-coloured carpet. Thinking about the structure of Honiton lace in particular, I decided that cutwork would be the way to suggest this in an embroidered piece. The different shades were created by dyeing one piece of wool flannel and three pieces of silk organza in brazilwood chips, using alum, copper and chrome mordants.

Details of circular panel (opposite).

The panel was constructed by layering the pieces of organza over the wool and tacking to secure. I machined the design through from the reverse using a metallic thread. The pattern was revealed by cutting away different layers of fabric to show the colour below. The last and most uncomfortable stage involved using very small, sharp scissors to cut away all of the layers of fabric between the flowers, stalks and leaves. I mounted the finished piece on a background of silk cotton from the same dyebath.

'Riverbed' 94 x 63 cm (37 x 25 in.).

The inspiration for this piece came from photographs of decorative stones and pebbles in gardening magazines. The colours of the delicate patterns brought to mind the soft shades of natural dyes. 'Riverbed' is now on permanent display at 'The British Geological Survey' at Keyworth, near Nottingham.

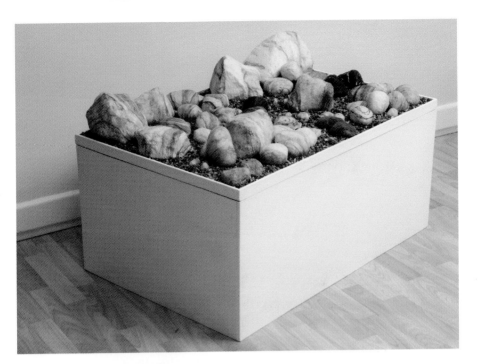

The piece was made for a college stand at the National Exhibition Centre, Birmingham. After making a few sample cobbles, it was suggested that they might be most effectively displayed on a large, white plinth. The geological collection expanded to include larger pebbles and irregularly shaped rocks. I decided to set them on a bed of alpine gravel because it reflected the colours used to pattern the stones – and the dry 'Riverbed' appeared. Most of the stones are made from mulberry silk-tops formed around a real stone or lump of rock. The darker stones are made from fine layers of dyed silk carrier-rods. I used very fine strands of dyed silk hankies to create all the patterning. The dyes used were: birch bark, madder root, turmeric/woad and alkanet.

103

Detail – Logwood cushions. 48 x 48 cm (19 x 19 in.).

These cushions were inspired by colour alone. The dramatic difference in the shades achieved on silk velvet when using logwood chips and three different mordants made a project irresistable. For the second cushion, I also dyed pieces of silk organza in the same way, because I wanted to vary the design by using frayed rectangles.

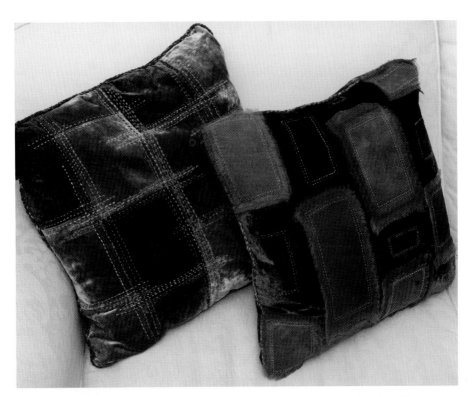

The first cushion was assembled from rectangles of silk velvet hand-stitched together. They were backed with interlining to stabilise the fabric but the stitching still had to be unpicked several times because of the extent that silk velvet travels when stitched right sides together. I added surface decoration in the form of running stitches along the seams, using various threads from the same dyebath.

For the second cushion, I used a single piece of alum mordanted velvet and applied layered and frayed rectangles of silk organza with running stitches.

105

'Suspended in time' Hanging – 109 x 66 cm (43 x 26 in.).

This piece was made in memory of my grandfather, who spent his working life repairing clocks and watches. The thread for the mesh background and the fabric for the clock faces was dyed with the dried flower tops of St. John's wort.

The mesh background was constructed using lengths of rayon-twisted thread machine-stitched onto heavy duty soluble fabric. The cogs, wheels and borders of the clock faces were cut from craft Vilene and painted with acrylics. I machine-stitched the Roman numerals on the borders in black thread and attached silk organza as a background for the decorative stitching on the clock faces. Real 'hands' were attached to quilted circles at the clock centres and the piece was finished off with a fringe of pendulums, some real and some cut from Vilene and painted to match.

Conclusion

My own passion for using natural dyes continues to grow with each discovery of a new dyestuff or different way of using plant material to add colour and pattern to textiles. It is always a pleasure to be invited to share my enthusiasm with others and, subsequently, to hear from people who have tried it for themselves, sometimes using no more than an old saucepan and a handful of flowers, leaves or vegetable trimmings to produce a worthwhile result.

Recipes for making natural dyes are not intended to be followed precisely to the last detail: they are simply a guide to enable the inexperienced dyer to make a start. Natural dyeing is a creative process in itself and experimentation will not only make the process more exciting but also increase confidence. Deviating from a recipe extends understanding and may suggest new and exciting possibilities.

In any case, your results will always be unique and, I hope, will represent the start of of your own personal journey into the fascinating world of natural dyes.

Glossary

16-count canvas Firm, even-weave canvas with 16 holes per inch, used for counted-thread work.

After-mordant A mordant that is added to the dyebath towards the end of the dyeing process.

Aquafilm Transparent, water-soluble fabric that will support stitching without the use of another background fabric.

Assistant (Usually) cream of tartar or dilute acetic acid (white vinegar) added to a mordant to increase effectiveness.

Cellulose fibres Fabric, yarn or thread derived from plants.

Dyebath The liquid dye.

Dyepan Large, metal container used for dyeing.

Dyestuffs Natural source material from which dye is extracted.

Exhaust Liquid dye that has been used at least once.

Fibres Fabric, fleece, yarn, thread or any other natural material, e.g. raffia, that is to be dyed.

Mordant Metallic salts used to fix the dye and improve the take-up of colour.

Needlelace A network of stitches across an open space, to create a lace effect.

Overdyeing Dyeing the same fibres more than once, using different colours on each occasion.

Pre-mordant A mordant used before starting the dyeing process.

Protein fibres Fabric, fleece, yarn or thread derived from animals.

Resist dyeing Blocking out areas of fabric, yarn or thread before dyeing to prevent the absorption of colour.

Scouring Washing, before starting the dyeing process, to remove any finishes from fibres.

Silk carrier-rods A waste product of the silk-winding process, flattened into split tubes, approximately 2x10 cm, that can be pulled apart to separate the fine silk fibres.

Simmering point 82°C (180°F)

Stumpwork Embroidery that is raised from the surface fabric by padding to create a three-dimensional effect.

Substantive dye Dye that will adhere to fibres without the use of a mordant.

Vat Large, lidded bucket or pan used for fermenting some dyes.

Vat dyeing Dyeing by a process of fermentation.

Bibliography

Buchanan, Rita, *A Dyer's Garden*, Interweave Press, 1995

Cannon, John and Margaret, *Dye Plants and Dyeing*, A&C Black, 1994

Casselman, Karen Leigh, *Craft of the Dyer*, Dover Publications, 1993

Dalby, Gill, *Natural Dyes for Vegetable Fibres*, Ashill Publications, 1992

Dean, Jenny, *The Craft of Natural Dyeing*, Search Press, 1994

Fereday, Gwen, *Natural Dyes*, The British Museum Press, 2003

Goodwin, Jill, *A Dyer's Manual*, Pelham Books Ltd, 1982

Hofenk de Graaf, Judith H., *The Colourful Past*, Archetype Publications Ltd., 2004

Prideaux, Jill, *A Handbook of Indigo Dyeing*, Search Press, 2003

List of Suppliers

Natural dyes, mordants and fibres

Fibrecrafts
Old Portsmouth Road
Peasmarsh
Guildford
Surrey
GU3 1LZ
Tel. 01483 565800
Web. www.fibrecrafts.com

Raw Fibres
Beacon Hill Farm
Raw
Whitby
N.Yorkshire
YO22 4PP
Tel. 01947 880632

The Mulberry Dyer
Maes Gwyn Rhewl
Ruthin
Denbigh
LL15 1UL
Tel 01824 703616

Aurora Silk
5806 N. Vancouver Avenue
Portland
OR 97217
USA
Tel. 503-286-4149
Web. www.aurorasilk.com

Prairie Fibers
627 7th Street
Ames
IA 50010
USA
Tel. 515-232-0912
Web. www.prairiefibers.com

Earth Guild
33 Haywood Street
Asheville
N.C. 28801
USA
Tel. 800-327-8448
Web. www.earthguild.com

Natural fabrics, threads and yarns

Whaleys (Bradford)Ltd
Harris Court
Great Horton
Bradford
West Yorkshire
BD7 4EQ
Tel. 01274 576718

Anglian Furnishing Fabrics
40 Magdalen Street
Norwich
NR3 1JE
Tel. 01603 624910
Web. www.anglianfashionfabrics.co.uk

The Silk Route
Cross Cottage
Frimley Green
Surrey
GU16 6LN
Tel. 01252 835781
Web. www.thesilkroute.co.uk

Uppingham Yarns
(Yarn merchants)
30 North Street East
Uppingham
Rutland
LE15 9QL
Tel. 01572 823747

Oliver Twists
22 Phoenix Road
Crowther
Washington
Tyne and Wear
NE38 0AD
Tel. 0914 166016

Hansons Fabrics & Crafts
Station Road
Sturminster Newton
Dorset
DT10 1BD
Tel. 01258 472698
Web. www.hansonsfabrics.co.uk

Sue Hiley Harris
The Crooked Window
90 The Struet
Brecon
Powys LD3 7LS
Tel. 01874 610892
Web. www.suehileyharris.co.uk

Fabric Hope Chest
593 Boston Post Road
Sudbury
MA 01776
USA
Tel. 978 460 0835

Sally's Shop
141 College Street
Wadsworth
OH 44281
USA
Tel. 330 334 1996

Dyeplant seeds

Wildflower & Countryside Centre
Bayfield Estate
Holt
Norfolk
NR25 7JN
Tel. 01263 711091
Web. www.naturalsurroundings.org.uk

Naturescape
Lapwing Meadows
Coach Gap Lane
Langar
Nottinghamshire
NG13 9HP
Tel. 01949 860592
Web. www.naturescape.co.uk

Index